How to
Paint the Chinese Way

How to
Paint the Chinese Way

Jean Long

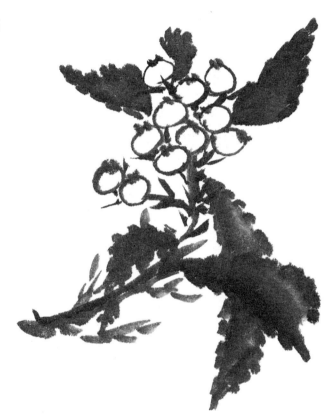

BLANDFORD PRESS
POOLE DORSET

First published in the U.K. 1979
Copyright © 1979 Blandford Press Ltd
Link House, West Street
Poole, Dorset, BH15 1LL

British Library Cataloguing in Publication Data

Long, Jean
 How to paint the Chinese way.
 1. Painting – Technique
 2. Painting, Chinese
 I. Title
 751.4'2 ND1505

 ISBN 0-7137-0999-5

Filmset in 12 on 13pt Bembo and printed by
BAS Printers Limited, Over Wallop, Hampshire
Bound by Robert Hartnoll Ltd., Bodmin, Cornwall.

Contents

Learning to Paint 9

The Six Principles 10

Equipment and its Use: 14
 The Ink Stone 16
 The Ink Stick 17
 Brushes 20
 Paper 29
 Colour 31

Flower Painting: 33
 Brush Strokes 34
 The Four Main Directions of Brush Movement 36
 Copying for Practice 42
 Poinsettia 43
 Cyclamen 46
 Brush Loading with Two or More Colours 48
 The Iris 51
 Plantain 55
 The Outline Painting Method 57
 The Chrysanthemum 58
 Hydrangea 61
 The Orchid 63
 Plum Blossom 67

Landscape Painting: 72
 Mountains 74
 Rocks 75
 The Four Chief Stages in Landscape Painting 80
 Use of Colour 86
 Perspective 88

Drawing Trees 93

Waterfalls 108

People and Things 110

Houses 112

The Twelve Faults 113

The Seal or Chop 114

Mounting the Painting 120

Selected Bibliography 127

This book is dedicated to all my students, past and present,
without whose encouragement it would not have been written.

Learning to Paint

In many ways learning to paint in the oriental manner can be compared to learning to play a musical instrument, such as the clarinet. A single note, or brush stroke is practised first, and then several notes or brush strokes are put together in the form of an exercise. Following this the budding musician will play a small piece, possibly accurately, but probably without any depth of feeling. This is what happens to the beginner in the Oriental art; simple flower pictures can be copied many times for practice with the emphasis on the actual strokes, rather than on colour or interpretation. After a great deal of practice more difficult compositions are attempted, but it is only the confident expert who will eventually feel able to interpret freely the works of the great masters and, having found inspiration in a specific subject, may feel impelled to venture into the realms of creativity for himself – namely by conceiving his or her own compositions.

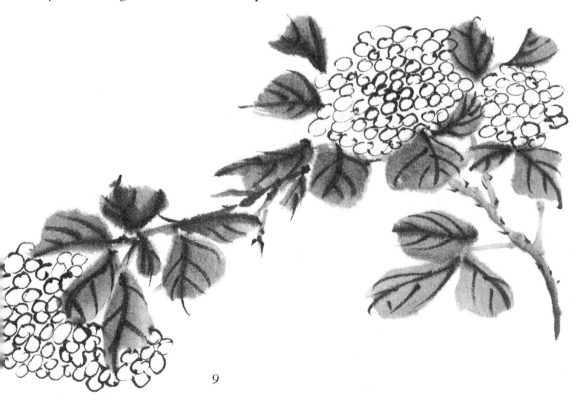

The Six Principles

For centuries Chinese artists have used the six principles of Hsieh Ho as the basis of traditional painting. Indeed, to a very large extent, the ethos has changed very little in the last 1500 years.

It is very difficult, of course, to translate abstract concepts from one language to another and even more difficult from an oriental culture to a non-oriental one: the ethics of parallel civilisations are infinitely varied and sometimes incompatible. However, it is essential to the technique of Chinese brush painting to understand these basic ideas, even if only in a superficial way; and to recognise that the order in which these ideas have been expressed is of great importance too.

FIRST PRINCIPLE – a painting should have life and vitality. After an artist has mastered the basic techniques of his craft, he is then able to bring an interpretative aspect to his work. Many of the great Chinese artists have used their paintings to convey their Taoist beliefs, a love and admiration of Nature in all its various facets, but certainly even the merest beginner puts something of his own thought and belief into his painting.

SECOND PRINCIPLE – the Chinese Brush should be used in a controlled manner.

This rule only serves to emphasise the importance of brush practice. The aficionado of Chinese brush painting always looks first at the individual brush strokes to see whether they have been correctly executed in the traditional manner, before considering the completed picture as a whole.

THIRD PRINCIPLE – the subject of the painting should be recognisable.

This statement is not as obvious as it appears. Firstly, it is not customary in China to paint with the subject of the painting in actual view. This applies to all subjects whether flowers, birds, animals or landscapes. A picture results from the image within the artist's mind and is not, therefore, dependant upon season or light or availability. Since the picture is not a copy from 'life', the colour also is a product of the artist's memory. However, whether the memory is good or bad, the subject must be recognisable to the viewer. Another aspect of this principle affects abstract painting, since it is a contradiction in terms to have an abstract painting which *is* recognisable. There are, therefore, no traditional abstract paintings. The third principle also accounts for the fact that, in general, the Chinese artist tends to restrict his painting to one subject area such as horses, prawns, monkeys, flowers etc.

FOURTH PRINCIPLE – colour, including different tones and shades of black, should be used carefully.

Traditionally the best brush strokes are always made with black ink on paper, while colour is shown to its best on the rather more difficult base medium of silk. It is most important to regard black positively as a colour and to use

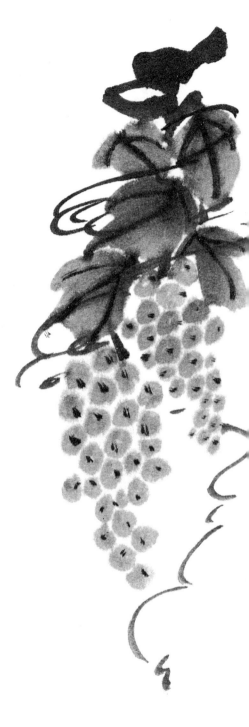

11

the many shades of grey to their best advantage.

FIFTH PRINCIPLE – the placing of the picture on the paper should be thoughtfully planned.

One of the most difficult aspects of Chinese painting for the Westerner to understand is the composition element. The general rule is that approximately two-thirds of the picture should be left unpainted. The importance of space is a fundamental concept in many oriental art forms and helps concentrate both mind and eye on the essential simplicity of the painting.

More space is always left above the painting than below, both in the actual painting if possible and when the completed picture is mounted into its final hanging form where a similar amount of space is allocated again in these same proportions. The unpainted area above the picture represents heaven and the space below is equated to earth. The painting itself is the connecting element which joins earth to heaven. This representational quality is an integral part of the composition, but is exceptionally difficult for a Westerner to grasp. (See the colour plates.)

SIXTH PRINCIPLE – practice and improvement is achieved through copying.

The oriental attitude to the ethics of copying are very straightforward. In the same way that one masters a musical instrument by practising scales, studies and pieces composed by many different people, so it is with painting. As an additional comparison, it may be possible, with practice, to play a musical composition with the same panache as its composer or to provide several sets of 'Variations on a Theme of Paganini'. There are copies of Chinese paintings in collections as greatly prized as if they were originals. Absolutely no stigma at all is attached to this method of learning and very many Chinese artists, famous in their own right, have composed masterpieces 'in the style of . . .'. For the beginner it is a great help indeed to feel free to practice by copying, particularly since it provides the most difficult element for the tyro to master, namely, the composition. The easiest trap to fall into is to construct a Western composition with Chinese brush strokes. This must be avoided at all costs. Many years of

practice are needed to achieve total control of all the elements necessary to master this art form, although very creditable results can be seen within a short time. The Chinese artist, with centuries of tradition behind him, will still feel humbly inadequate to aspire to original compositions without a very great deal of practical reference to the work of the great painters of the past. It is one of the drawbacks of Western civilisations that they feel the need of immediate achievement without the necessary time being spent on the developing in-between stages.

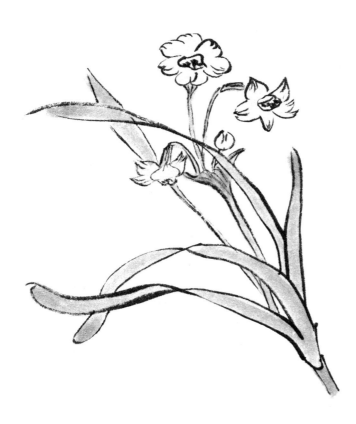

Equipment and its Use

The basic requirements are few and long lasting – an ink stone, ink stick, brushes and paper. These are known as the 'Four Treasures'. In addition the painter requires water colours, a water container, a palette or plate and newspaper or blotting paper.

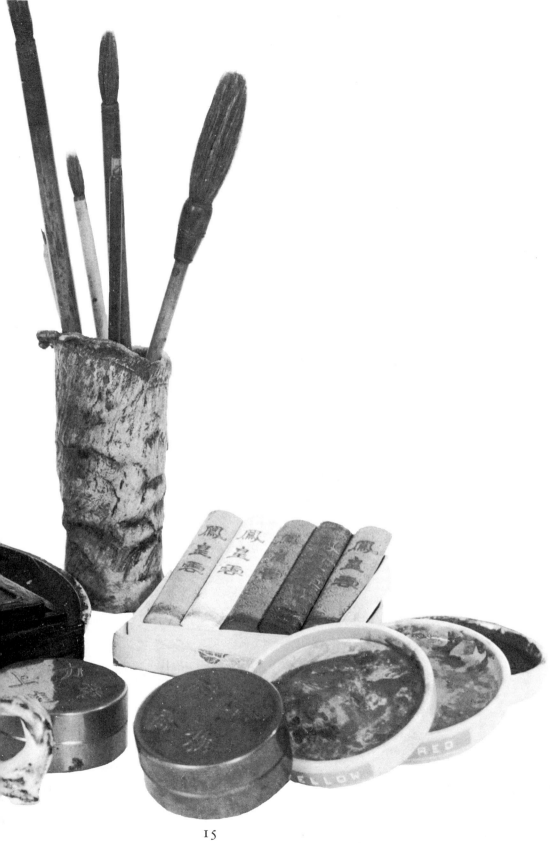

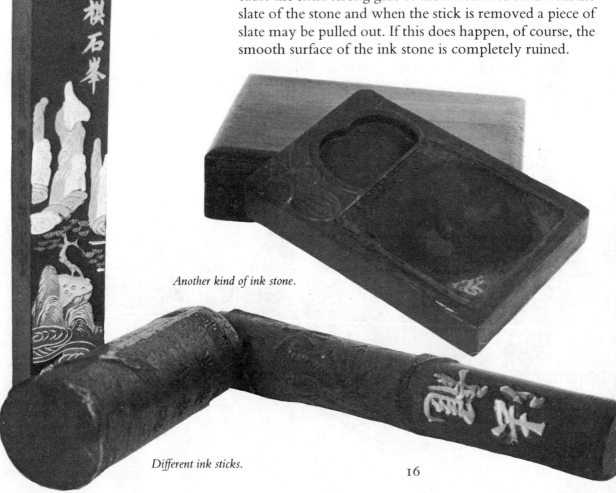

The Ink Stone

Non-porous slate is the usual material for the ink stone. Various areas of China lay claim to the best type of slate for the purpose, while there are also many other decorative substances used, such as jade. However, in essence, the requirements of the ink stone are a flat surface on which to rub the ink stick and normally a small sunken area which serves as the water well. While it is not customary to wash the ink stone each time it is used, it does become imperative to clean the grinding surface as soon as the dried old ink begins to collect in the corners.

No special cleansing equipment is required – just wash clean in running water, taking care not to drop the ink stone at any time as the slate will crack and break if dropped. One other hazard to be avoided is that of leaving the ink stick standing on the stone while wet. This will cause the extra strong glue of the ink stick to bind with the slate of the stone and when the stick is removed a piece of slate may be pulled out. If this does happen, of course, the smooth surface of the ink stone is completely ruined.

An ink stone

Another kind of ink stone.

Different ink sticks.

The Ink Stick

Although various coloured pigments can be purchased in the form of solid sticks, it is usually specifically black to which Oriental artists refer when discussing the ink stick. Since black is so important to all Chinese painting, the quality of the ink used has always been vital. The main ingredient is pine soot which is collected from burning pine branches when the wood is at an optimum age – not too young, not too old. The black powder is mixed with a special gum and moulded into sticks of varying shapes and sizes. There is no particular reason for the fact that some ink sticks are round while others are rectangular, but the size used is determined by the amount of ink needed at one time for a particular painting. A painter of horses, intending to complete a massive hanging scroll, obviously would need both a large ink stick and a large ink stone in order to grind enough ink quickly to make the sweeping strokes necessary for the subject. There are, of course, different qualities of ink stick; some, whose ingredients include ground pearl and powdered jade, are very expensive and may well be intended more for decoration than for usage. All sticks, however, have some form of calligraphy embossed on them and usually an animal or landscape as well.

Using the Ink Stick and Ink Stone

To make ink it is first necessary to put water in the well of the ink stone. Then, using small drops of water on the flat surface of the ink stone, rub the ink stick firmly in a circular motion. Approximately half a teaspoon of water will require about two hundred circular rubbings of the ink stick. Quite a lot of pressure is needed to grind the ink off the stick. The ground ink mixes with the water on the ink stone to form charcoal black ink and is correctly mixed when it assumes an oily consistency and separates from the stone. More water can be added while continuously grinding the stick until the required amount of smooth ink has been made. Inevitably the liquid evaporates if not continuously used, so it is often necessary to make fresh ink

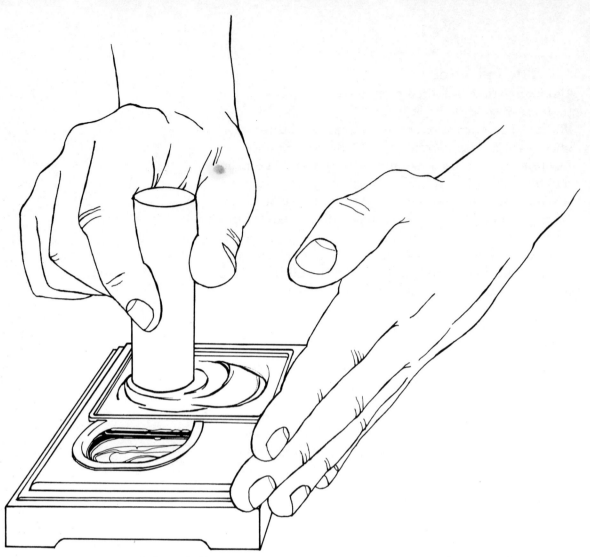

Rubbing ink and guarding ink from splashing.

several times during the course of completing a painting. It is advisable to hold the resting hand by the side of the ink stone as a guard against accidental splashing which may occur during the ink rubbing. This can happen if the ink stick is tilted so that the edge catches the stone and causes the ink to splatter.

It is an amazing fact that the more practised a person becomes at grinding ink, the blacker the colour becomes. A quick rub with the ink stick is not sufficient; if the ink is not as black as possible, then the painting can never be as good as it should be. While the grinding is taking place, the painter should be thinking about the potential subject matter and composition, so that when the ink is ready, so is the artist. Manufacturing the black ink is almost mesmeric in its intensity of concentration as well as the additional bonus it performs – that of loosening up the finger, hand and arm muscles ready for the brush manipulation to follow.

Questions are sometimes asked as to why it is not possible to use black water colour paint or bottled indian ink. One of the reasons is that the quality of fresh ink is vastly different from that of pre-manufactured liquid, since additive materials in both bottles and tubes impair the original consistency of the colour. Above all, the most important pre-requisite of Chinese ink ground on the ink stone is its ability to be reduced by the addition of water to seven controlled, essentially differentiated shades of black.

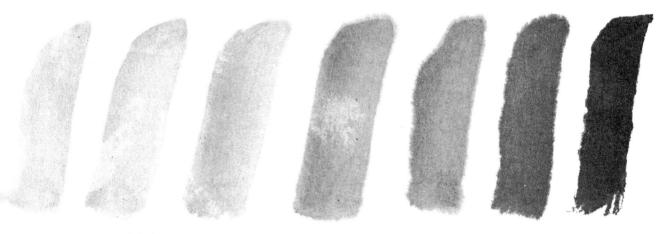

The seven shades of black.

Brushes

Only a Chinese brush is capable of producing all the varieties of strokes necessary to cover the full range of possibilities inherent in Chinese painting techniques.

The basic essential is a brush which has been specially cut to a point. The average brush has its hairs packed quite solidly, enabling several strokes to be made from one loading of the brush. Since the full length of the brush is used to make the strokes, the size of the painting can well be dependant upon the size of the brush used and there are many sizes available, the numbering system usually, but not always, increasing as the brushes become smaller and finer. Handles are usually made of bamboo, a natural material which is very light and unaffected by continual immersion in water.

The brush hairs, always of natural material, can be of many kinds, ranging from sheep's hair to goat's hair and even including mouse whiskers. In fact, apart from the question of availability which obviously affects the price of the brush, the main consideration is the way the brush has been made, rather than the material used for the brush hairs. Very fine work must necessarily be attempted with a brush with few hairs, while the larger hanging scroll requires a brush proportionate to its size. The Chinese brush can be pushed back against itself in the course of a stroke without the hairs splitting or being damaged. The Japanese brush, although similar in many respects, cannot do this because, although it is still cut to a point, its hairs are not packed together in the same way. For many purposes the Japanese brush will be satisfactory and indeed it is vital for Sumi-e (Japanese brush painting), but, there are basic differences between the two oriental art forms.

Three brush sizes.

20

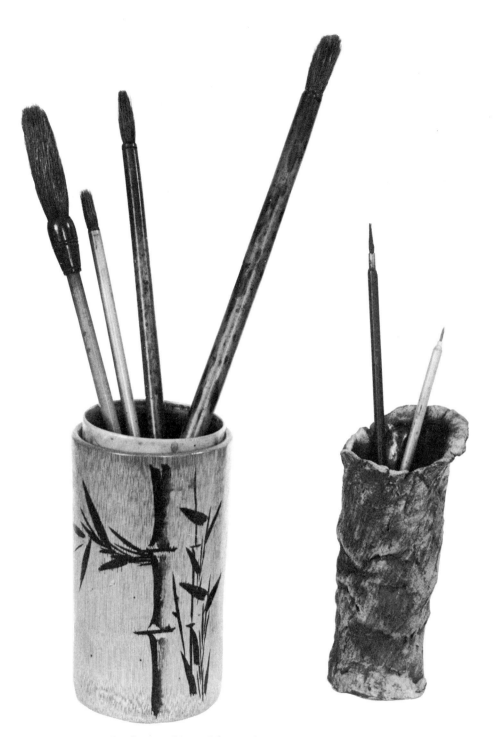

Brushes stored in upright containers.

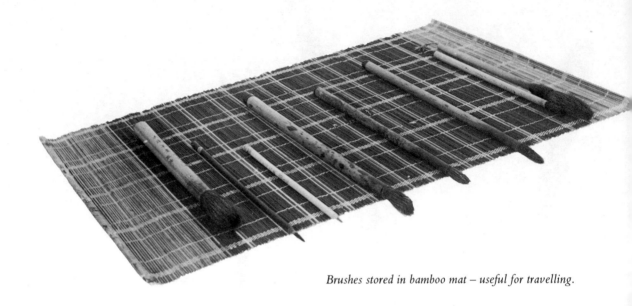

Brushes stored in bamboo mat – useful for travelling.

All brushes are sold with a cap of some kind to guard the bristles of the brush whilst it travels. Once a brush has been used, however, the bristles will expand and should not be forced back into this cap, otherwise hairs will be bent and broken. Storage is usually in a ceramic pot, bristles upright, or brushes can be kept in a rolled bamboo mat. Obviously brushes should be kept clean – old, dried ink is very gritty and can damage a brush – but in normal circumstances, the brush should last for years, almost to the time when the point is completely worn away.

Use of the brush

Some new brushes contain stiffening materials in the bristles. These must be washed out carefully (gentle manipulation of the brush hairs helps to speed the process) so that the brush is soft and pliable. Take care not to use hot water which may soften the glue which holds the brush into the handle.

Brush Loading

Correct brush loading requires time and patience. If it is rushed then this fact will immediately be evident from the brush strokes, so always be specially careful to load correctly.

Most strokes require the full bristle length of the brush so ink or paint must be mixed to the correct consistency in a fairly shallow bowl or plate with an edge large enough to accomodate the bristles. Then, roll the brush between the fingers so that the bristles are fully soaked with paint. Maintaining the brush point at all times, gently scrape the outside surplus off the brush by stroking the bristles against the plate edge; this also serves to push the liquid into the centre of the bristles. Repeat this soaking and stroking procedure several times until the brush contains the amount of liquid necessary to achieve the desired brush strokes. These instructions are basic to brush loading, but the ink varies in intensity as required for the dry brush strokes used in landscape painting, the wet strokes that make large leaves, or the thin lines required to indicate boats or people.

Brush being loaded in small ceramic pot.

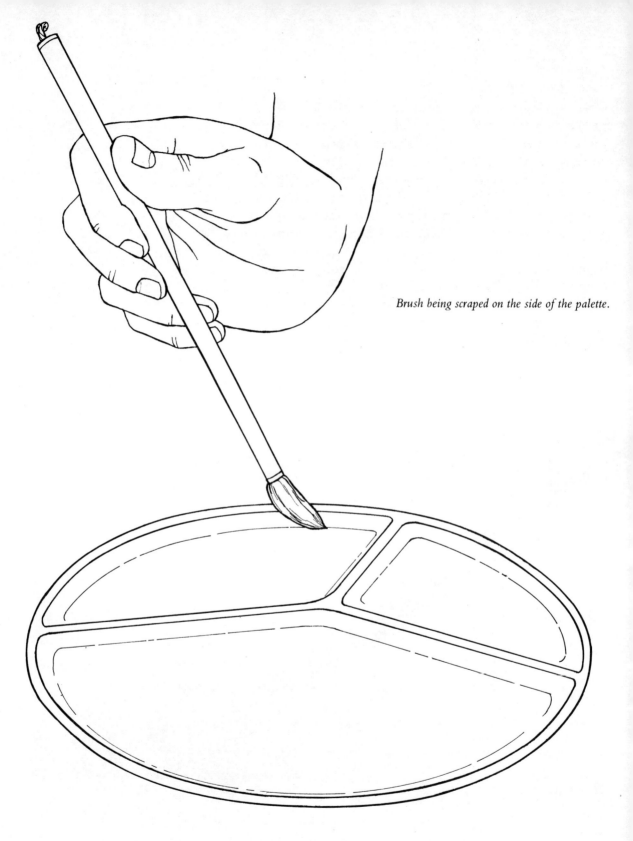

Brush being scraped on the side of the palette.

Wet Brush Strokes (Brush loaded with a lot of ink). The ink runs loosely into the paper.

Medium Brush Stroke The edge of the stroke is clear and clean.

Dry Brush Stroke (Very little ink on the brush). The brush skims the paper, thereby allowing the brush to miss the paper in some places. This is sometimes called 'flying white' and can be used to show the grain of a tree or the texture of a mountain. Great care should be taken not to use this technique excessively.

Graduation of tone in one brush stroke is best illustrated in the colour plates.

A common difficulty occurs when changing from a wet brush stroke to a dry one. Following a series of large wet strokes it is best to remove all surplus liquid by blotting on tissue or squeezing the bristles gently before loading again for the dry stroke. Remember always to maintain the brush point; some Chinese painters lick their brushes continuously to keep them in shape, but this has its dangers when using poisonous pigment colours. As with all the techniques of this traditional art form, only practice will enable the painter to judge whether the brush is loaded correctly. It is as well to remember also that all stroke painting errors need not necessarily be due to incorrect brush loading, as many other factors are involved which will be dealt with later in the book.

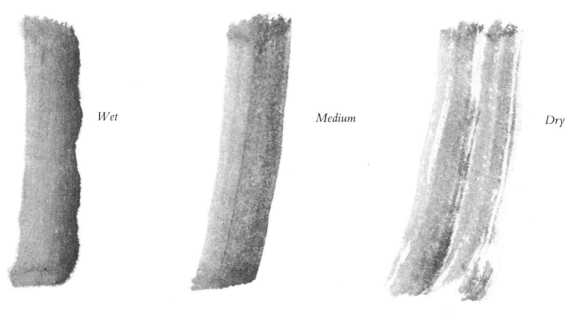

Wet *Medium* *Dry*

The three brush strokes

Brush Holding

In many ways the brush grip is similar to the method of holding chop-sticks, so obviously a person whose eating habits are based on the handling of a knife and fork will not find it easy to acquire facility in the use of the brush. However, brush control is only achieved by the correct use of the traditional techniques, so it is necessary to persevere.

Always make a point of beginning each stroke or group of strokes with the brush held vertically. The grip is achieved by bending the first finger, allowing the brush to lean on the knuckle joint and holding the handle in place with the upright thumb. The second finger is then placed to the right of the brush and the third finger to the left. The fourth finger is not on the brush itself, but positioned under the third finger. In the vertical position the hand leans backwards from the wrist almost making a 90° angle between the arm and the hand. With the brush held in this position, a space is formed in the palm of the hand of sufficient size to hold an average egg.

The position of the fingers on the brush can be varied by moving the grip higher up the handle for large, free flowing strokes and lower down for small delicate strokes. In general, brush movement originates in the upper arm and shoulder, so it is essential that no part of the brush-holding hand or arm rests on the table during stroke production. Most of the traditional Chinese paintings are impressionistic in essence, so it is very important to achieve these free flowing brush movements. If the painter is working too close to himself, or even leaning too far away while holding the brush, this will also affect the strokes as the former impedes movement and the latter causes lack of control.

Brush Usage

When the brush is poised ready for use, the best form of practice is to paint lines of different thicknesses, leaning the brush handle in the direction of the stroke. Try both wet and dry strokes and vary the speed and pressure so that it is possible to see the different effects obtained from these basic variables. Dots and circles also provide interesting

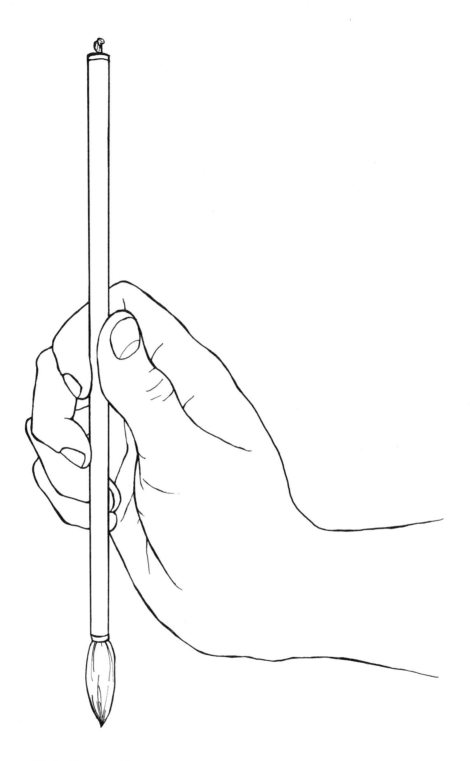

Vertical brush position.

insights into the effects of brush on paper. Control of the brush requires continual practice as different pressures or changing angles produce varying strokes. The wet brush must be moved swiftly and lightly over the surface of the paper to prevent too much liquid soaking into the absorbent paper, so any brush stroke made is an unchangeable commitment.

Specific stroke construction for each different petal and leaf will be described individually later in the book.

Paper

The essence of Chinese painting – the brush stroke – is shown at its best on paper rather than silk, so it is very important to choose the correct paper; the vital element is absorbency and different types of paper have different degrees of absorbency. It is the action of the brush on the paper which produces the traditional strokes so admired through the centuries. Obviously, therefore, different papers produce different results and each needs to be used so that the painter can become accustomed to the various effects achieved by pressure and variable brush loading. Traditionally papers had rather picturesque names, but nowadays it is more usual to ask for paper by the name of its natural fibre base – rice paper; bamboo paper; mulberry paper etc. Even so, treatment with size (a substance which binds the fibres together and gives paper its 'surface') or different manufacturing processes means that each batch of paper made is slightly different from the previous batch. Paper can be bought in rolls in three different widths, or in sheets. Most paper has one side which is smoother than the other and it is best to use this as the painting surface. It is possible, though very difficult, to obtain sheets of coloured rice paper, although in general the dyeing process alters the absorbency of the paper to a very high degree.

Using The Paper

The paper should be cut to the size you require, whether from a sheet or roll, and then the remainder should be put carefully to one side, away from the danger of water or paint splashes.

Since it is so absorbent, this paper cuts better with scissors than with a knife.

Having selected the correct size of paper, it should be placed flat on newspaper or blotting paper. The paper surface underneath absorbs the surplus ink from the strokes, so it is important that this paper too should be absorbent; if it is not it will repel the liquid and cause it to run back uncontrollably into the masterpiece above it. Anyone who is worried that the print from the newspaper

will mark the painting paper need have no doubts on that score, as it is oil (such as the oil in your skin) which causes the print to be removed from the newspaper; water alone will not be sufficient, so it is quite safe to use with the rice paper. One hazard which may not often occur, but is worth a warning, is that of ball-point writing on newspaper; this will cause severe marking, and happens when old newspaper, possibly belonging to a crossword addict, is used.

It is essential that the painting can be moved up and down while it is being completed because the actual painting strokes have to be executed at the correct distance, so the paper has to be moved along to maintain the optimum attitude. Therefore the paper must not be fixed either on to its base or on to the working surface. One reminder at this stage is to treat the paper carefully; the brush strokes should glide over the surface without scraping the top layer of the paper off. This particularly applies when a wash is being painted over a large area.

In addition, the consistency of the paper requires that the paint or ink is not applied too thickly. The reason for this is that a permanent bond is effected between ink and paper which will resist running, provided that the paint has been absorbed and is not layered thickly on the paper's surface. This is particularly important in view of the method of mounting Chinese paintings.

Colour

In Chinese texts prior to the sixth century BC colour was very important and related to the five elements, to the seasons, to materials, to planets and to animals as shown in the following list:—

1	black	water	tortoise	north	winter	mercury
2	red	fire	phoenix	south	summer	mars
3	green	wood	dragon	east	spring	jupiter
4	white	metal	tiger	west	autumn	venus
5	yellow	earth	dragon	centre		saturn

The ideal paint for use in a Chinese painting is that made from natural minerals pounded up and combined with clear glue and boiling water. Nowadays, however, scientific progress has been such that we no longer need to resort to such a long and difficult process. Special Chinese colour sticks can be purchased with the four basic elemental colours (without black) and an additional blue stick. These are ground on a grey stone in the same way as the black ink stick. Sometimes a china plate or tile can be used to grind off the colour, which is softer in consistency than the black ink stick.

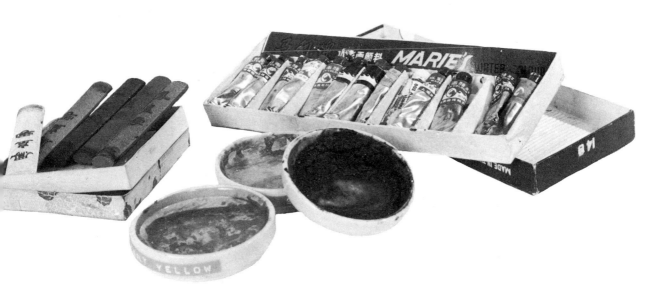

Colours: ink sticks, tubes and ceramic pots.

These colours are pure and ideal for use on both paper and silk, but the tubes of Chinese water colours are also satisfactory. As far as modern Western proprietary brands of water colour are concerned, testing is advisable, because occasionally the man-made additives which help to produce colour fastness, or maintain the paint freshness, are themselves the cause of running in absorbent paper.

Use of Colour

Water colours must not be used thickly on absorbent paper – it is essential to mix the paint with water to the correct consistency for each individual stroke. Chinese white is often used to give depth to another colour and black can be a great help in providing a natural tint to leaves and stems or to darken colours.

It is also possible to load two or three colours at once on to a chinese brush, so that the tones and shades are achieved in one stroke. This is explained on p. 48.

Flower Painting

The most important characteristics of Chinese flower painting are:—

1 the feeling of peace and tranquillity
2 the importance of space
3 the perfection of simplicity

There is a required painting order which must be followed:— flowers first, then leaves, with the stems to be added as the last item.

It is helpful when constructing the various elements which make up a plant to work always from the growing point, either outwards in the case of the flower head, upwards or downwards as appropriate in the case of the leaves and from the growth area towards the flower head for the stem.

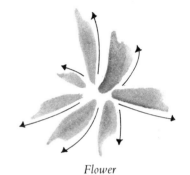

Flower

Half-open flower

Bud

Leaf

Leaf

Stem

33

Brush Strokes

Controlled brush strokes are the essential elements of all types of Chinese painting. These strokes were refined and perfected over a long period of time until, eventually, they became accepted as the best method of representation for flowers, leaves and stems. You should practice thoroughly the three simplest strokes, shown at the bottom of the page, until you can produce them with some degree of fluency. These strokes are very important, because, with minor amendments and alterations, they form the basis, not only for a great number of flower paintings, but also for birds, fish and animals.

Before describing the actual construction of each stroke, I must emphasise the importance of correct loading of the brush, whether it is with ink or water colour paint. Experience has shown that this aspect of painting receives very little attention from the would-be painter, who is only too anxious to get started. A little extra time and thought at this point will pay dividends in the long term. Check that the brush has been loaded correctly for each of the three strokes to be practised.

Petal Shapes

These strokes are the result of the variable distances moved by the brush tip before the rest of the bristles are lowered on to the paper.

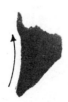

No distance

Short distance

Long distance

FINISHING THE STROKE

Brush tip straight off.

Brush tip turned before leaving the paper.

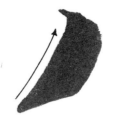

Brush twisted in the hand and turned as the tip is leaving the paper.

PETAL SHAPE – Instructions for the use of the brush:—

Loading – brush lightly loaded.

Direction – brush tilted in direction of intended movement.

Method – put brush point on to the paper, then lay bristles down, move along, take brush off paper.

Speed – a steady even movement, not too fast, nor too slow.

Pressure – let the brush glide gently over the surface of the paper.

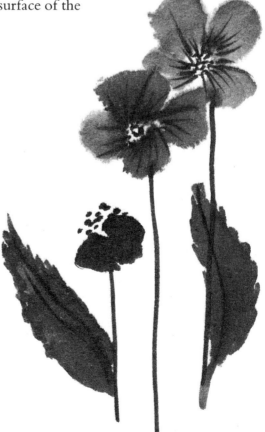

35

The Four Main Directions of Brush Movement

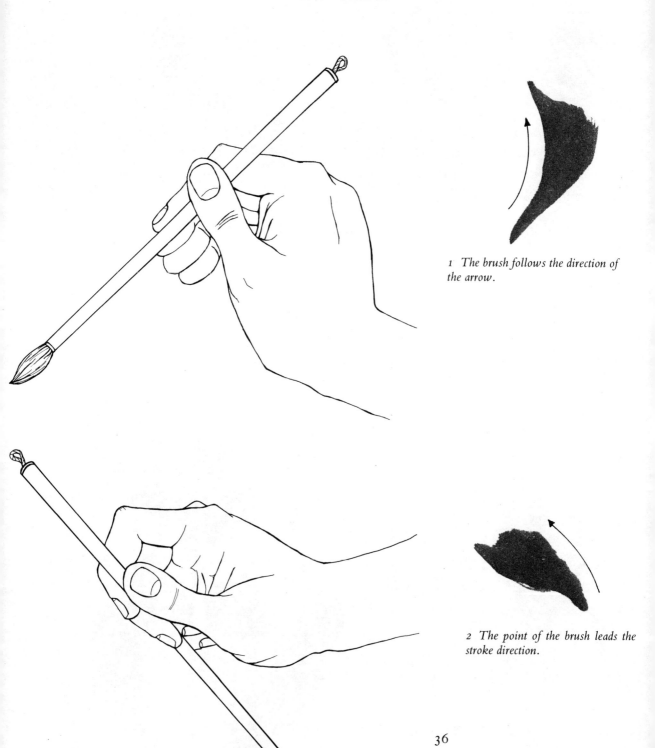

1 The brush follows the direction of the arrow.

2 The point of the brush leads the stroke direction.

3 The heel of the brush controls the width of the stroke.

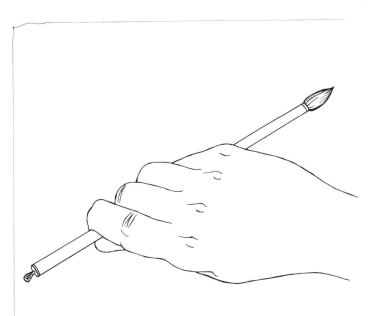

4 The inside of the stroke (following the arrow) is smoothly continuous, while the outside of the stroke varies.

Leaves

These strokes are the result of the slow movement of the saturated brush, the maximum leaf width determined by the length of the bristles.

THE LEAF – Instructions for the use of the brush:—

Loading – heavily loaded, rather wet.

Direction – tilted in the direction of intended movement.

Method – put brush point down, lay all bristles down and pull full length of the brush along before slowly raising brush from paper – the tip is the last to leave.

Speed – rather slow to allow the ink to run into the paper.

Pressure – some pressure is needed so that the paint will run into the paper.

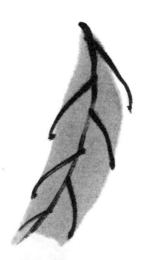

Vein lines down the centre of the leaf.

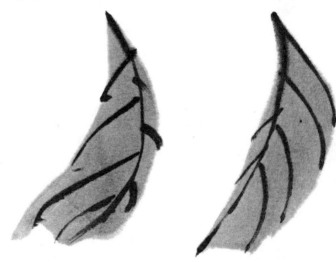

Changing the position of the main vein alters the apparent shape of the leaf.

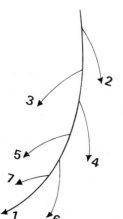

The order of painting is shown in this diagram.

38

A Basic Leaf Stroke

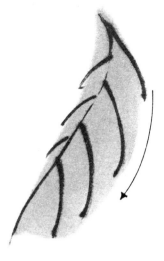

Veins added when the leaf shape is at the correct degree of dampness so that the veins appear to be an integral part of the leaf.

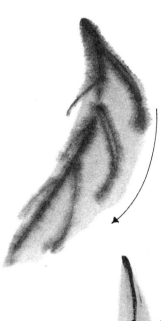

Veins added when leaf was too wet, causing excess moisture to run.

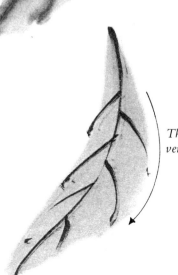

This leaf was dry when the vein lines were painted. Therefore the veins appear totally disconnected from the leaf.

Different Types of Leaves

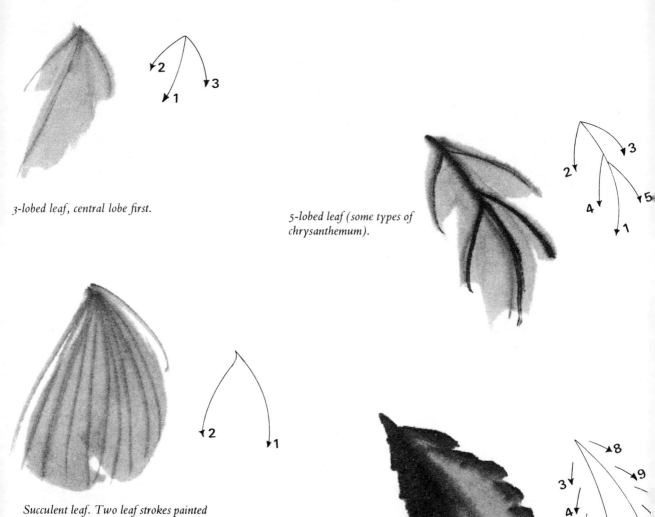

3-lobed leaf, central lobe first.

5-lobed leaf (some types of chrysanthemum).

Succulent leaf. Two leaf strokes painted to join together. Veins all painted from the same top point.

Two leaf shapes, one dark, one light, painted to join together, with small leaves added on the sides to give a serrated edge.

Stems

The brush, held vertically, is pushed towards the flower or leaf. The stem width is achieved by allowing the necessary amount of the brush hairs to rest on the paper during this movement.

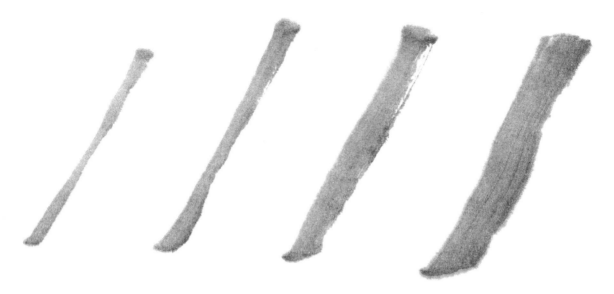

The illustrations above show different stem widths. Notice that all these stems begin with the brush put flat on to the paper, and stop with rapid and immediate removal of the brush from the paper.

Instructions for the use of the brush

Loading – enough ink to be able to complete the stem length without re-loading.

Direction – brush to be held vertically.

Method – put brush hairs to required width on paper and push in the direction of growth. Remove in one movement at the end of the stem.

Speed – steady, smooth movement, usually upwards.

Pressure – light and even but firm, with a positive beginning and end.

Copying for Practice

A word here about the Chinese practice of learning by copying. It is, of course, very difficult to learn a lot of new things all at once and one of the purposes of using a model for practice is to remove some of the more obvious difficulties so that more time and thought may be allowed for stroke practice.

The most difficult aspect of Chinese painting for a non-oriental person is composition. Basically, therefore, it is the composition which should remain static while the strokes are allowed to vary. The main aim should be to group the flowers within similar spatial constraints, maintain a proportional relationship with regard to the size of paper being used, and concentrate on forming correct strokes. At this stage the leaves are also grouped around the flowers very closely to maintain a compositional balance, so aim to keep this idea in mind while forming your own leaf shapes. On no account add extra flowers or leaves 'because it looks empty'. If motto there be, it should consist of 'If in doubt, leave it out'! The following pages demonstrate a continuously developing pattern of strokes in order of difficulty, so try to master one flower design before proceeding to the next.

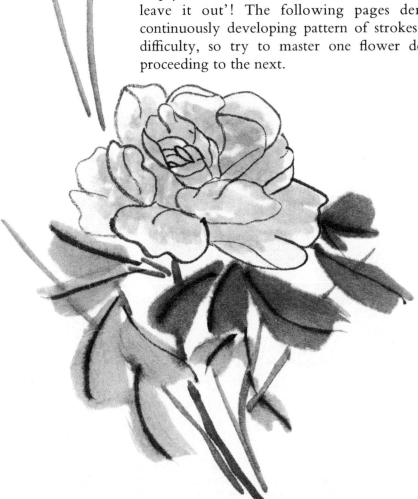

Poinsettia

A suitable flower with which to begin is the poinsettia. Since everyone 'sees' colours differently it is important for the initial emphasis to be on the brush strokes, not on the colour or the difficulties of balancing five equal petals in the correct proportion.

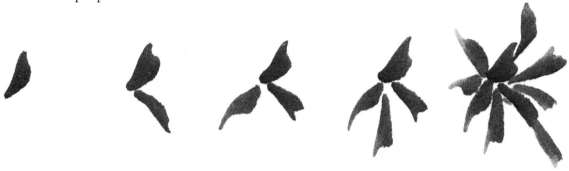

With the brush loaded with red water colour, fix the position of the centre of the first flower and, painting from the growing point, work generally in the order shown above. All petals, short or long, should be painted starting from the flower's centre. Re-load the brush when required. Petals must *not* overlap otherwise too much liquid will overload the absorbent paper and the paint will spread in an uncontrolled manner. The water colour paint should be diluted so that when the brush is correctly loaded light and shade will be already contained in the stroke. The tip of the brush will normally contain darker colour than the other end of the bristles, particularly if the stroke is always commenced from an upright position.

Complete one flower before beginning the next one. The 3-dimensional impression will be helped if you paint flower petals shorter on one side. Leaves can be painted in grey, or alternatively, mix some colour such as green or blue with some light ink. This time the brush should be loaded to a much wetter consistency so that a softer stroke will result. Paint the leaves as shown on p. 44, adding the veins to the leaves with black taken directly from the ink stone and loaded on to the point of the brush only.

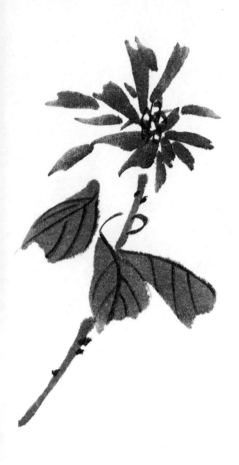

Sometimes it may be necessary to stop after painting a few leaves and put in the veins before going on to the next leaves. The speed of drying will vary with the type of paper being used and the prevailing atmospheric conditions. Add the veins, remembering to vary the position of the main vein to prevent monotonous shapes resulting.

For the stem, load the brush with dark grey, grey-green, grey-brown or any other suitable colour combination. As the brush is pushed towards its destination, be ready to remove it if there is a leaf or flower impeding its path and re-start the stem again on the other side of the obstruction. Since the general tendency is to practise flowers and leaves diligently, but omit to put the same amount of practice time in on the stems, often the following faults can occur:—

1 Not loading the brush with sufficient ink (running out in the middle of the stem or a too dry stroke).
2 Loading with too much ink (stem is too wet and ink runs uncontrollably).
3 Non-positive stroke (hand shakes and so does the stem).
4 Not aiming the stem correctly towards the flower. (Try practising in the air before allowing the brush to touch the paper.)
5 Attempting to 'touch up' or join a broken stem or a 'too thin' stroke. (Better to leave a blank space than to do this.)
6 Parallel stem lines. (No cure – remember next time to think before you paint.)
7 Awkward appearance. (Stems should be near to each other at the beginning of the stroke.)

As you will realise, a lot of practice is needed to become confident in the production of good stems.

To complete the picture several more strokes are needed. First, the leaves are connected to the stems with a small casual, curving line as shown at the top of the page. Then, place small black dots (the ink taken directly from the ink stone and loaded on to the tip of the brush only) at random on the stems, to indicate where a leaf has dropped off, or some other natural flaw has occurred. These are

called 'mi dots' and apart from their value to the beginner as a remedy for some accidental mistake, will detract attention from some of the stark, clean lines of a stem too carefully executed.

The flowers should now be absolutely dry and you can add small oval lines indicating the centre of the poinsettia. Since black lines are 'hard' they will stand away from the larger petals helping to create an effect of depth. Special care must be taken with these last strokes as they focus the softness of the petals into the centre of the flower. The ovals may then be filled in with yellow to complete the poinsettia.

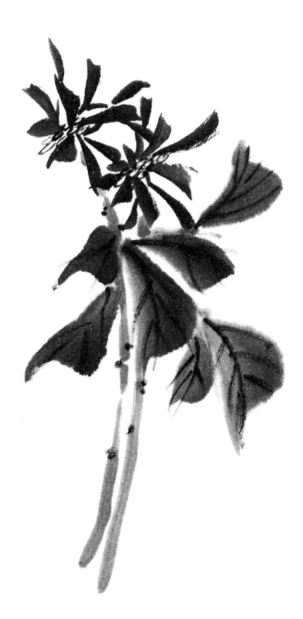

Cyclamen

A wild variety of cyclamen makes an interesting study in brush techniques. The flower with its pale pink blooms, is formed using the same basic petal strokes as the poinsettia. The order of painting is as follows:—

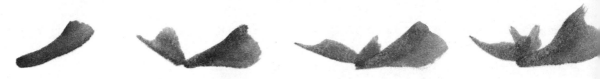

This plant has a fat succulent leaf which can best be painted with a large brush loaded with dark blue. If the brush still contains some pink from the flowers, do not wash it all out; the colours will merge giving shading effects. If the dark blue has a touch of watered black, this also adds to the colour interest. Using the full length of the bristles, the brush point remains in one spot, while the bristles are rotated to form the leaf. If a large brush is not available, then this succulent leaf shape can be achieved by constructing two joining leaf shapes. A slight overlap is not unsightly, nor is a slight white space if it results naturally from the stroke structure.

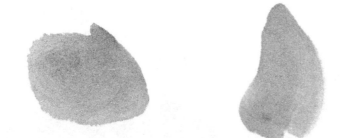
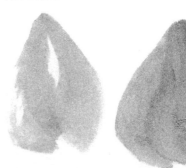

The leaves should grow near the flowers, rich in their profusion. Before the leaves are completely dry, add the veins, using the point of the brush loaded with black ink directly from the ink stone. Keep the pressure light and the veins will be firm without looking hard and dry. All veins start from the same growing point and curve gently to give the leaf shape.

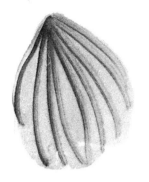

Direction change at the leaf centre.

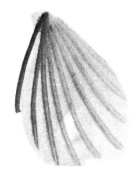

No direction change.

Veins closer together on one section of the leaf give the impression of more solid thickness.

Addition of the stems allows, in the case of the cyclamen, for some artistic licence, as botanically each leaf and each flower has a stem of its own. This would make for great overcrowding in a painting, so give stems to only the flowers and buds, painted from the area of growth upwards. The composition can be drastically affected by the positioning of these stems, so care and prior thought are essential.

The final touches to the composition are provided by the stamens and pollen dots. A fine brush, loaded with a dark pink or red, is lightly flicked upwards for each stamen, after the flower is totally dry. These stamens then appear to stand away from the flower because of their clean, hard lines in contrast to the softness of the petals. A few pollen dots should be added for each flower, painted with the soft wet tip of a fine or medium brush, with just enough pressure for the dot to be soft and round. These dots represent pollen grains and are as different from grains of pepper, salt or sand as chalk from cheese, so be careful with these final touches – not too large, nor too small, but just right for the size of the flower.

Brush Loading with Two or more Colours

One of the most effective techniques produced by the use of the specialised Chinese brush is that of double brush loading. You will also find it useful in any type of water colour painting as well as in pottery decoration.

It is best to use a medium or large brush, in which the bristles are packed quite thickly. A 'rose brush' is a special Chinese brush with shorter length bristles used for the petals of the peony rose. This can also be double loaded, but it is not suitable for the distribution of three colours.

First make sure that the water colours to be used are ready mixed with water as though to be loaded onto the brush in the usual Chinese manner. For two-colour strokes, load the brush with the lighter of the two colours and then gently scrape the top section of the brush on the side of the palette so that this section is lightly loaded only. Now finish the loading by rolling the brush tip in a darker colour. The demonstration strokes opposite have two very different shades of black on the brush so that the structure can easily be seen, but in practice it is better not to have too much contrast between the colours.

Three colours can be loaded onto a Chinese brush, the tip being loaded with the third and darkest colour. The areas where the colours merge into each other produces a very natural effect.

Suitable uses for these effects are in leaves in colour combinations of green and brown as seen in the colour plate 'Chrysanthemums', and in flower petals, either intentionally or even accidentally (see colour plate 'Roses').

Monochrome pictures should also have variations of grey and black loaded onto the brush so that in effect light and shade are contained in each stroke.

As many strokes as possible should be painted from one brush loading. Then the brush must be completely emptied of paint and loaded again from the beginning. Not all the leaves or petals need to be multi-coloured – the occasional plain one will help set off the complexity of the shaded ones.

Under no circumstances should colour be added to the

49

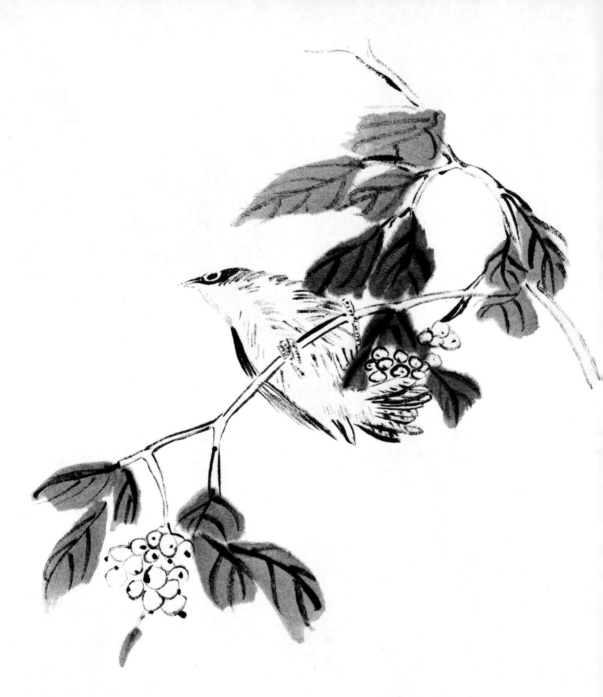

basic stroke in an attempt to achieve shading. Over painting or corrections will spoil the free, impressionistic fluidity of the Chinese brush strokes, so any such temptation must be firmly resisted. As with all aspects of Chinese painting techniques, practice is the key to success.

The Iris

The modern iris has been highly developed and its varieties are colourful and decorative. From the painting point of view the simple wild iris, rather similar to an orchid, is the best type to use as practice.

Using a medium brush, loaded with pale blue water colour (blue and Chinese white combined), the flower is constructed using the basic petal stroke.

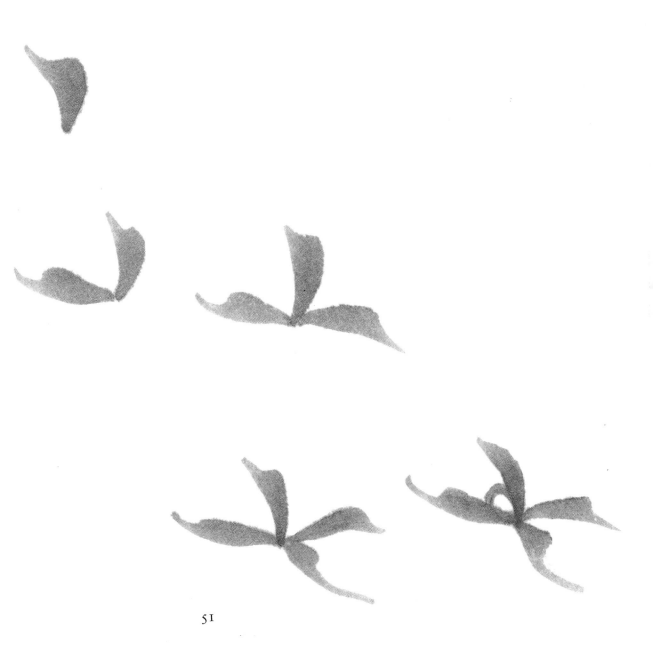

Dots or decorative lines can be added to the flower while it is still wet, and yellow pollen dots can be painted on with the tip of the brush.

After painting several flowers and buds, the brush has to be loaded for the leaves. As the leaf is long and thin, the brush must contain sufficient colour (possibly a mixture of grey/green or brown/green) to be able to complete the entire leaf in one stroke, but an over-saturated brush will cause running or unwanted thickness.

Pull the brush firmly but gently over the paper until the end of the envisaged leaf is required and then lift the brush from the paper so that the tip leaves the paper last. If the leaf is to bend, then pull the brush in the direction necessary.

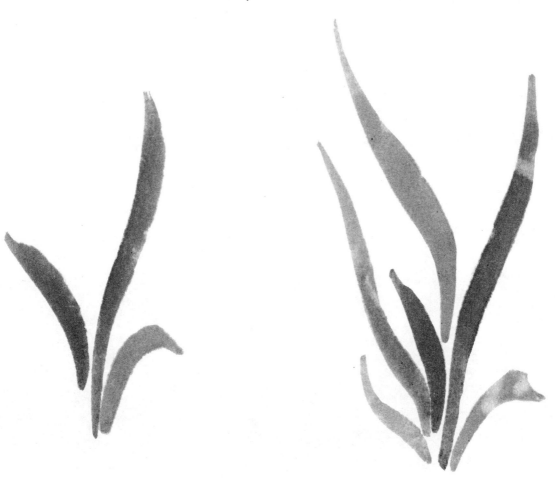

Faults to Avoid:—

1. Leaf ending is split, not pointed. (Cause – lift off not smooth.)
2. Parallel leaves.
3. Leaves crossing over the top of others.
4. Leaves growing from a base area which is too scattered.
5. All leaves the same length and width.
6. Leaves too similar in colour to each other.
7. Composition spreading out too much. (Cause – leaves bending outwards too far.)
8. Proportion of leaf size to flower size incorrect.
9. Composition too crowded.

It may seem, reading this large list of possible faults, that the iris is an extremely difficult flower to paint. This is not so. Practice will show immediate improvement and, if you consider each fault, you will find that most of them can be avoided. Long thin leaves such as these are very elegant as pottery decoration and are later developed further when you come to paint orchid leaves. After thin lines (drawn with a lightly loaded brush held vertically) have been painted from the growing flower clump to each individual iris or bud, the painting is finished – unless you wish to add black vein lines to the leaves. These lines are optional and, in fact, change the painting from a delicate design to a much more positive composition. The lines can be added continuously or in dotted form (much more difficult) and can be arranged to give the leaves a more twisted appearance. It is not advisable to be too careful with these lines or the composition will appear very contrived.

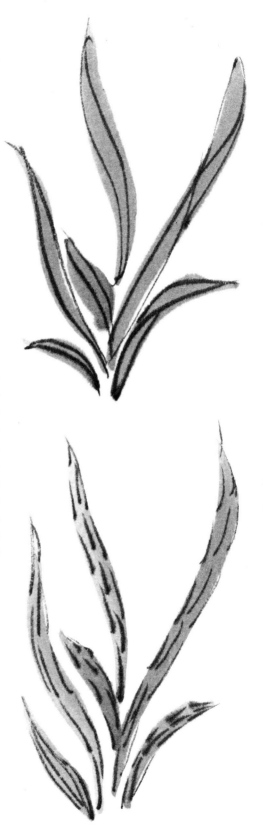

53

The iris is well worth a great deal of practice as both flowers and leaves are the basis of other stroke constructions.

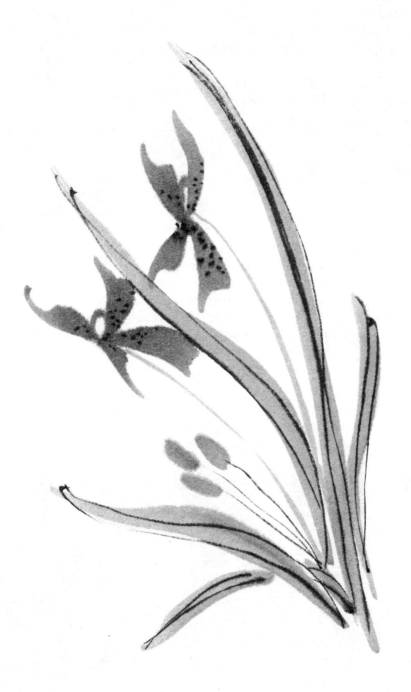

Plantain

This is a blue flower with five petals. To the inexperienced artist, the problem of arranging these five petals to fit into a circular format may seem overwhelmingly difficult. However, there is a simple method of approach which can help make this task much easier. An imaginary line is drawn through the centre of the flower and the flower is then arranged with three petals on one side of the line and two petals on the other.

The brush loading for this flower is very important as the stroke requires that the point of the brush remains on the paper while the rest of the bristles rotate until the petal is completed.

Beginning the next stroke close to the previous one, but not touching, lay the brush on the paper and move gently, but positively, anti-clockwise. The fourth and fifth petals are completed in a similar manner. The composition requires several flowers in groups, some half hidden by other blooms.

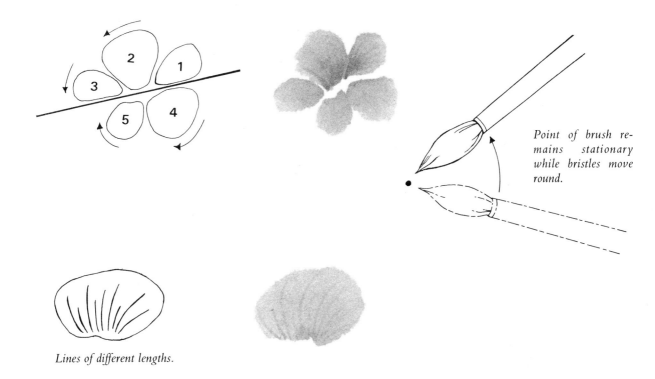

Point of brush remains stationary while bristles move round.

Lines of different lengths.

While the flowers are still damp, the thin brush, tip loaded with dark blue, inscribes shaping lines to give movement and depth. A long gently curving stamen strikes out from between the petals. Now add orange/yellow pollen dots, scattering them gently around the end of the elongated stamen. Place a few yellow dots in the centre of the flower using a medium brush. There is a temptation here to use the water colour paint too thickly – resist this or it will cause running problems during the mounting process. The leaves lash out from the flowers in straight pale green swathes. Pull the brush along, with a straight lift off which will give a stubby, rounded end. Variable lengths of leaves and careful direction produce a 'sunburst of green'. One vein line runs through the centre of each leaf.

Paint a thick woody branch appearing from the back of the flower group. This branch is achieved by a push stroke made with a medium brush thickly loaded with dark ink. Very interesting bent branches are the result of pauses and changes of direction during the push stroke. Many of the impressionistic flower compositions have a very positive design content, and this particular grouping is effective both in colour and in various shades of black.

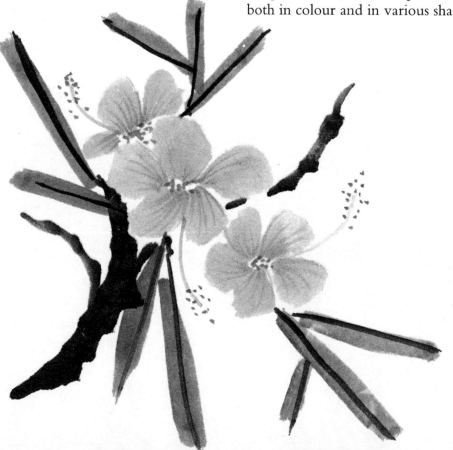

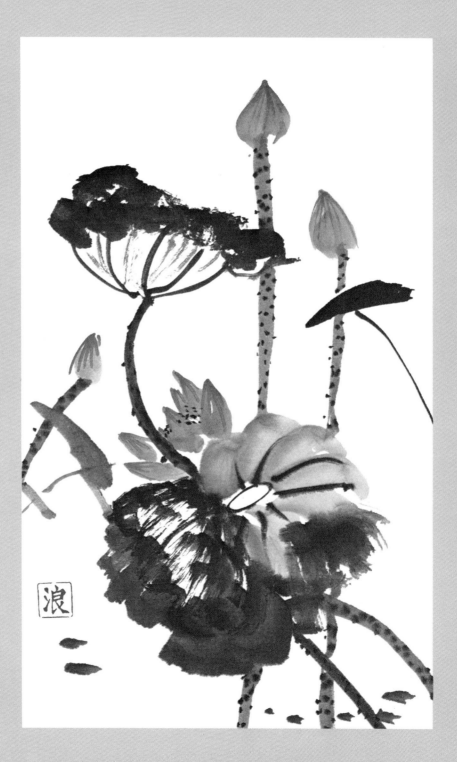

Lotus

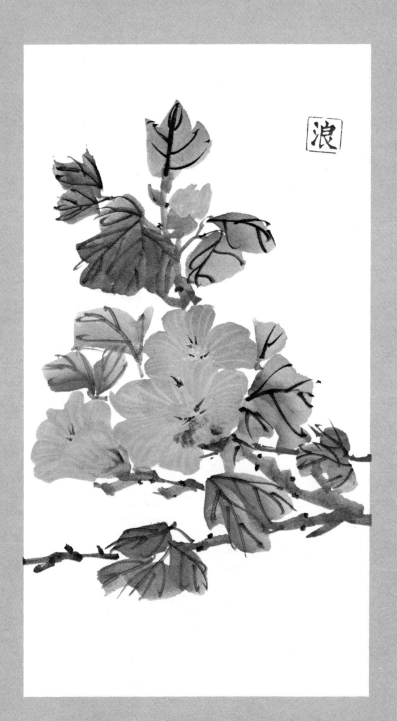

Hibiscus

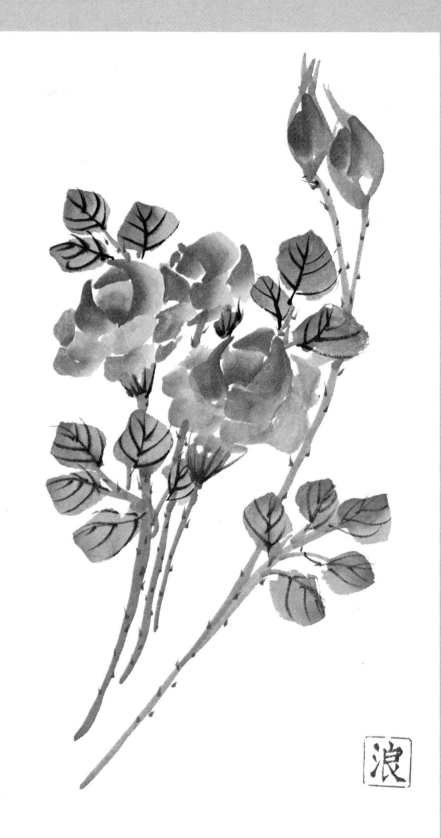

Roses

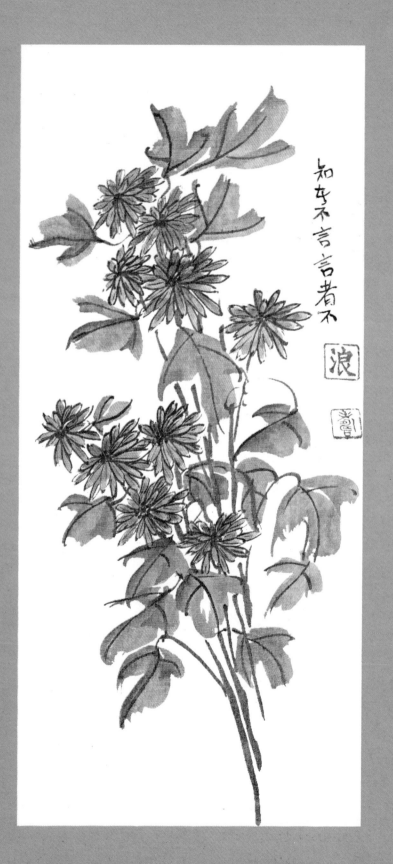

Chrysanthemums.
Painted on silk.

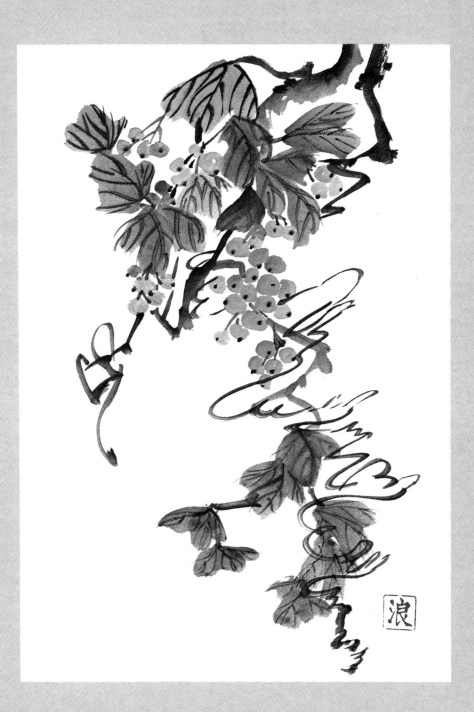

Grapes

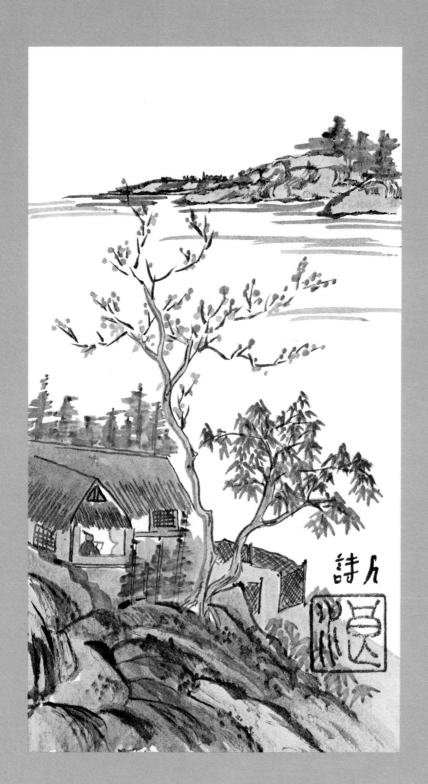

The Poet

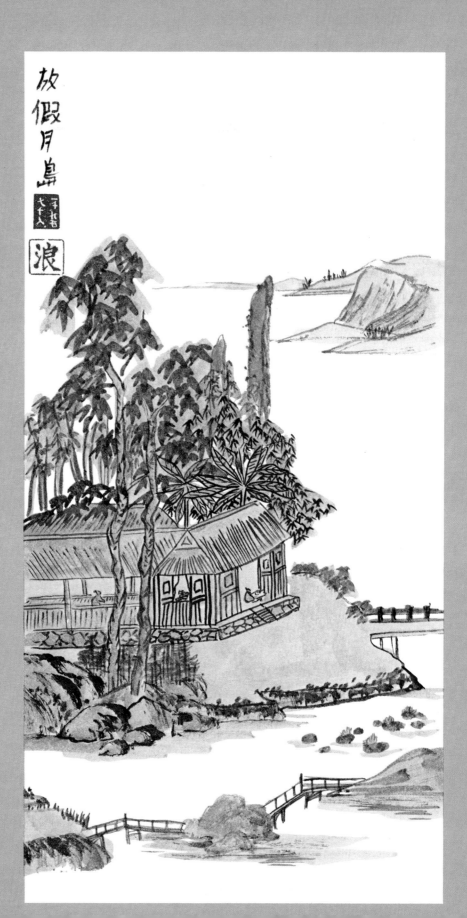

Holiday Island

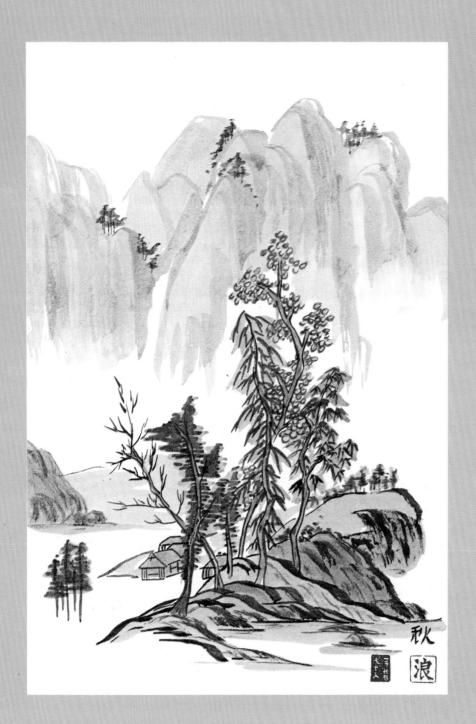

Autumn

The Outline Painting Method

There are two methods of painting flowers, the one stroke method and the outline method. The one stroke method of approach has already been used for both the flowers and the leaves of the poinsettia, cyclamen, iris and plantain. The alternative outline method, although it can be used for both flowers and leaves in one picture, is normally employed for *either* the flowers *or* the leaves in one painting. In essence it can be compared to drawing with a brush, although this is not strictly accurate as the brush movement and direction affect the thickness of the stroke. Brush loading for painting outlines is different from that used to paint leaves and petals as, obviously, only the tip of the brush needs to be loaded. For the beginner it is easier to use thick, black ink directly from the ink stone. Great care should be taken not to exert too much pressure on the brush when producing these lines – brush pressure causes the ink to be pushed into the paper and this can result in thick lines. A light touch along the surface will enable you to produce finer lines.

The Chrysanthemum

This flower is so important to the Chinese people that it is regarded as one of the 'Four Gentlemen of Chinese Painting'. The chrysanthemum, together with the bamboo, the plum and the orchid, embodies the virtues of strength and beauty even in adversity. Since the T'ang dynasty in AD 618, this flower which blossoms in spite of the wind and the frost in the difficult autumn season, has become instantly recognised as an embodiment of the simple oriental art form.

Since it is not customary in China to paint with the flower as a living model, the form and characteristics of each individual type must be known. The artist has both to study and to love the chrysanthemum in order to be able to convey readily his remembered impressions on to paper. This method of 'mind painting' has both advantages and disadvantages. On the credit side, one is not sidetracked or distracted by the necessity to match colour shades exactly, or be dominated by the direction and intensity of the light. Flaws are no longer remembered so do not have to be recorded, which can only be an advantage. However, it is necessary to develop a high degree of observation and interest and a very selective colour sense. The peculiarities of this system of painting account for several facets of Chinese painting : the tendency of artists to specialise in very specific subjects e.g. horses, monkeys, prawns, bamboo etc., and also the great length of time which elapses before an oriental person considers himself to be artistically competent in one particular branch of painting.

Our modern hustle and bustle must be abandoned, for a slower more natural life style if success is to come in the field of Chinese painting. Careful study of the flowers as they change with the seasons leads to an appreciation of the continuing pattern of nature and a fascinating new awareness of the beauty of the chrysanthemum. This type of study in depth will be helpful in all flower painting as one becomes aware of the particular characteristics of each flower.

A chrysanthemum flower is made up of many petals radiating out from the centre and spread out in circles

which eventually build up to form the full flower head. As the petals are added stroke by stroke, the flower grows before your eyes. Using the outline method, start from the centre of the flower and paint each petal in two strokes. A fine brush loaded with dark ink directly from the ink stone is the best way to begin. It is necessary to load only the tip of the brush since it is a fine line which is required.

Make the petals slightly different lengths until the circle is completed.

Add more petals in between the first layer.

 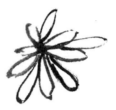 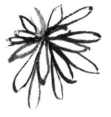

Buds can also be constructed in the same way.

Groups of flowers and buds are arranged together in groups of three or five, depending upon the size of the flowers. (See colour plate of 'Chrysanthemums'.) Next in the designated order of painting are the leaves. Chrysanthemum leaves are either three-lobed or five-lobed. Remember that nature is rarely perfectly symmetrical, so if each section of the leaf is slightly different in size and shape the overall result will be better than if each lobe is exactly the same. When all the leaves have been added, the

main stems are placed carefully, using the basic 'push stroke'. Then each unattached leaf is joined to the stem, always painting *from* the central leaf vein *to* the main stem. This chrysanthemum picture can be left as a monochrome picture, or the outlines can be filled in with colour. Any colour can be used, or even two if desired, but the water colour must be gently delicate in shade, not thick and heavy. Fill in the spaces rather roughly so that parts of the white paper still show through, and a very realistic flower will result.

Each type of chrysanthemum has different characteristics. Some are flat with thin petals, some are small and round with tightly packed petals, and others have delicately flowing curving petals, while the shape of the flower head can vary from dome-shaped to disc-shaped. Another type of chrysanthemum which lends itself to this type of painting is the spider variety. Thinnner longer petals point upwards to the sky and elegant spiderish petals weave their way downwards, interlacing as they go. The most difficult area in the construction of these flowers is in the centre. Be careful not to form a darkened area where too much painting has overlapped.

A favourite type of composition is one which combines chrysanthemums with rock, as the gentle softness of the flower is thrown into high relief by the dark strength of the rock structure.

Hydrangea

The hydrangea consists of small four-petalled flowers. These small flowers group together to form a large flower head whose colours of pink, blue or lavender make a very fine and colourful display. Either flower painting method can be used for these flowers, with the rather large leaves which frame the flower head being painted in the 'one-stroke' technique.

The flowers cluster together naturally in such a way that occasionally not all the four petals are on view at the same time. Think of the flower as growing from a centre outwards and build up the florets accordingly. The final shape should be relatively round, but not circular. One of the problems to avoid is that concentration on the actual strokes can be so intense that, before you realise it, the flower may grow out of all proportion into a monster of the giant sunflower type. A fine brush, loaded with dark ink directly from the ink stone is the easiest method of outlining the florets, although it is also possible to use a lighter shade of black, or even a colour for the flower heads.

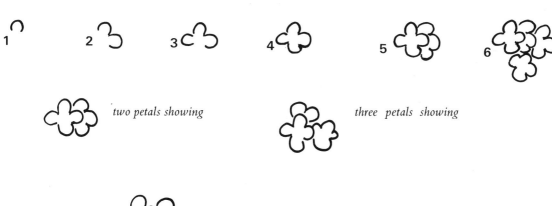

two petals showing

three petals showing

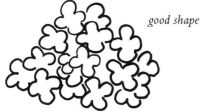

good shape

Usually more than one flower is necessary for a good composition. Each should be different in size and shape from the other, but if unsure, then always place the heaviest, largest flower towards the bottom of the group. The flower heads should all be very close together. The next stage is to add leaves, beginning near the flower heads. Each leaf is a simple basic stroke framing the flower. The first leaves should begin as close to the flower head as possible without actually being allowed to touch it. Remember not to paint one leaf over the top of another, but stop and start again on the other side of the leaf.

The stems should not be too long as the intention is to suggest a small group of flowers from a large bush. Paint from the bottom of the stem towards the flower, stopping where leaves cross the path of brush movement.

Once again it becomes evident that to achieve simplicity requires care and attention to detail and also continuous concentration from the beginning to the end of the painting.

The Orchid

Chueh Yin, a Buddhist monk of the Yuan period, suggested that the painter in a happy mood should paint the orchid because 'the leaves grow as though they are flying and fluttering and the buds open joyfully'.

The most difficult part in painting the orchid is the achievement of the long leaf strokes; so, unlike other flower painting compositions, the leaves are painted first. The grass orchid species which has only one flower on each stalk is called 'lan' and its leaves grow in tufts of not more than seven, while several orchids on one stem, the marsh orchid, known as 'hui', has leaf clumps of not more than eleven blades.

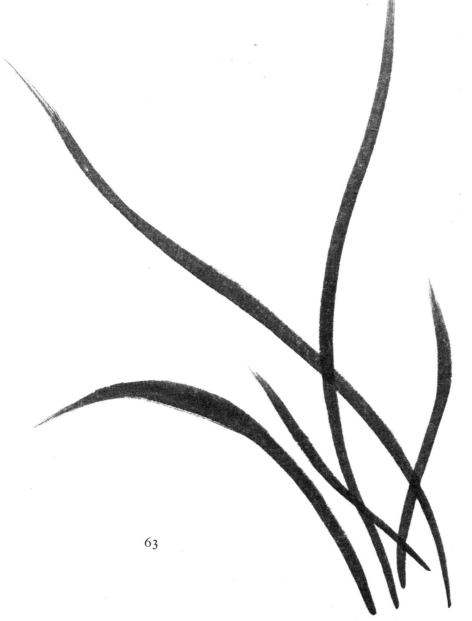

63

There is a special order of painting for the leaves:—

1 the first stroke in an arc
2 the second stroke crosses forming the 'phoenix eye'
3 the third blade goes between to 'break the eye'
Others are then added.

The leaves should be darker than the flowers and not all of the same length. Sometimes a break may occur in the stroke; this does not matter and in fact illustrates the Chinese principle that there is continuity of idea, even if a break in its execution occurs. (The Chinese description of this is rather clever – 'idea present, brush absent').

The orchid can be painted growing from a rock, or near a brook, or just growing from the ground, but the leaves must be graceful and curved, almost, in fact, a complete composition in their own right.

Orchid flowers are usually lighter in colour and tone than the leaves, and the flower petals should have dark tips to them. The five-petalled flower should not be painted like an outstretched hand, but like fingers with one or two curled across each other and some straight. The larger petals are straight and broad, while the smaller, narrower ones curl. The stamens, the heart of the flower, are painted like three dots and vary in position according to the direction in which the orchid flower itself faces.

The 'Orchid' is one of the 'Four Gentlemen' of Chinese Painting and those who look at the work of the ancient masters can see why it is said that 'the brush dances and the ink sings'.

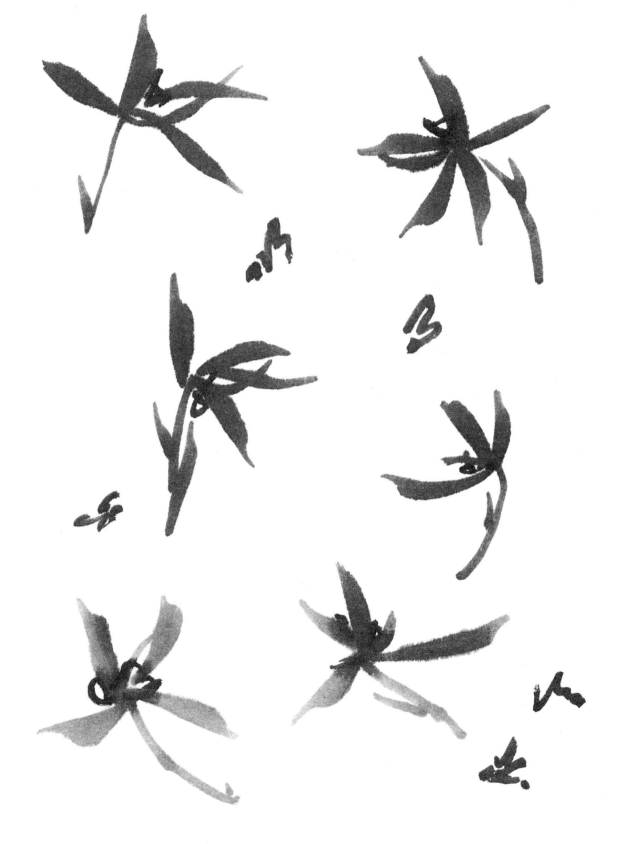

65

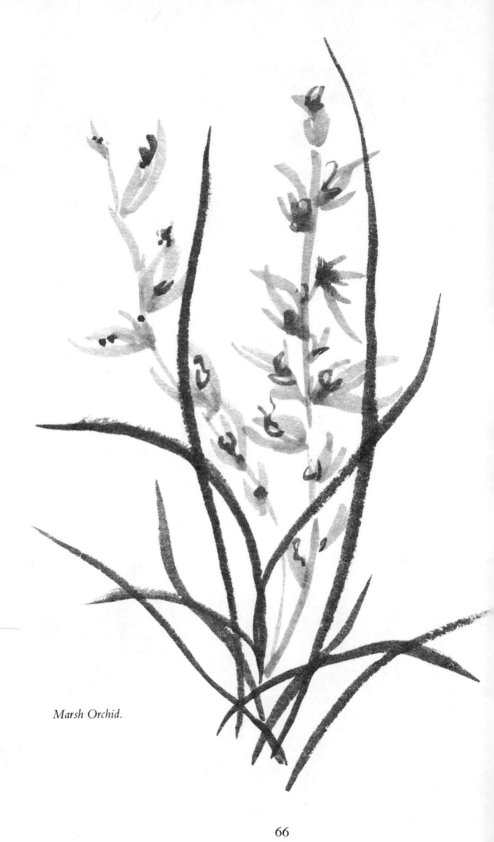

Marsh Orchid.

Plum Blossom

One of the 'Four Gentlemen of Chinese Painting' is the Plum, the others being Orchid, Bamboo and Chrysanthemum. Each of these different living plant forms represents characteristics regarded by the Chinese scholar as worthy of emulation.

Plum blossom in its different stages of growth, together with its developing trunk and subsidiary branches represents the continuity of life. The delicate flowering blooms appear to be at one with the January frost, symbolising hope and endurance. It is not customary to devote an entire composition to one tree, but to show, by means of a small group of branches, a microcosm of its entire existence. A twisted, gnarled trunk bears slim, elegant branches, which in their turn, sprout young shoots, buds and blossoms in all their many aspects.

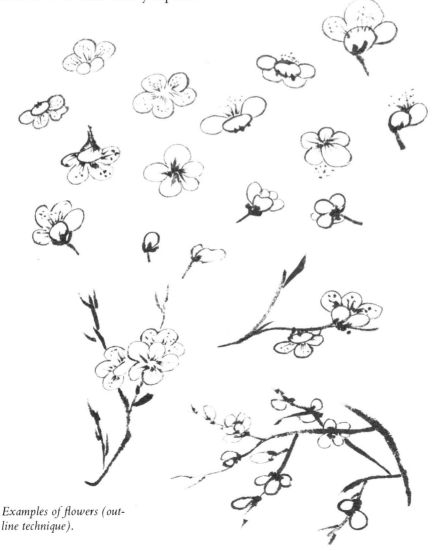

Examples of flowers (outline technique).

Time is crystallised, encapsulated into an evocative composition in which a few lines and simple strokes tell all. Nowhere is the ideal of space, which is so much a part of Chinese painting, more beneficially shown than in a plum blossom composition. The space is integral to the design itself. At any moment buds may open filling one space, while another dies and falls to the ground, leaving its scent lingering in the void which will be left. Yang and Yin, the Chinese concepts so basic to its painting, is epitomised here. Dark, heavy, old twisted trunk, contrasting with light, young straight shoots; the soft roundness of the blossom enhancing the straight hardness of the branch. Symbolically, the plum is regarded as having two trunks, one large and one small, with the bud representing Heaven and Earth in a form undivided by the appearance of Man.

The main branches symbolise the four seasons and tend to face in towards the four directions of the Universe. It is a tree with dignity.

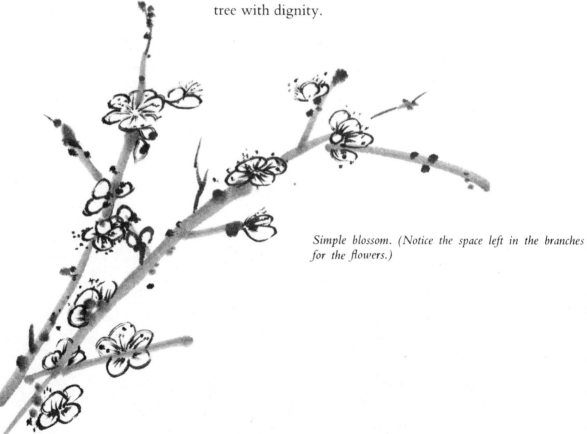

Simple blossom. (Notice the space left in the branches for the flowers.)

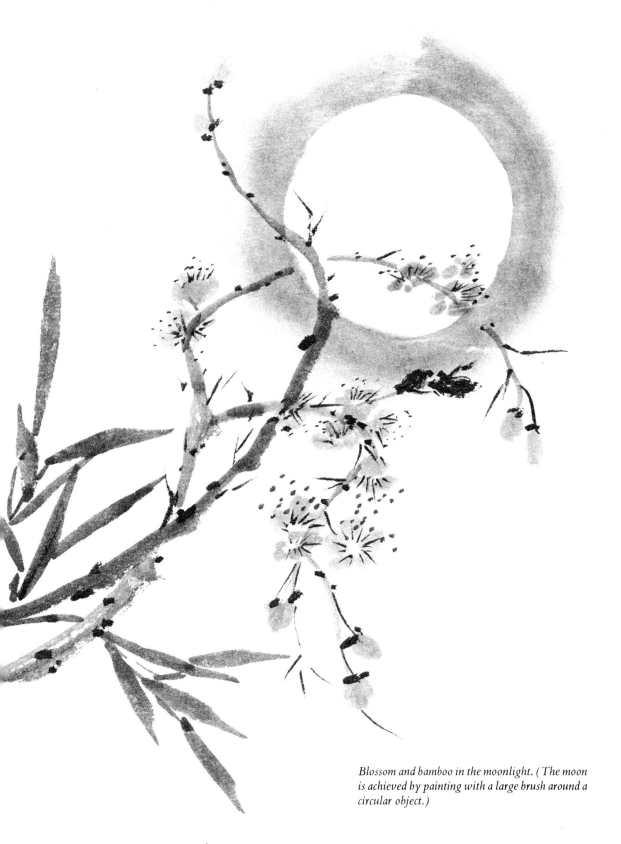

Blossom and bamboo in the moonlight. (The moon is achieved by painting with a large brush around a circular object.)

Instructions for painting the Plum are almost poetic. Fresh tips of branches are luxuriantly covered in blossom, the flowers and buds being small in proportion to the thickness of the trunk or branch. Where branches connect or fork, they mingle busily together. Branches do not grow in opposite directions from the same point on the trunk. It is customary when painting this subject to paint the branches first, leaving spaces for the blossoms to be inserted later. This calls for a very clear concept of the composition as a whole before you start. It is not an easy subject to capture, but it is always worth the effort.

The blossoms can be formed in many ways, wide open or about to drop, fully formed or merely buds; there is no limit to their variety. The form of the blossom has been compared to the 'eyes of a crab', 'grains of pepper' or sometimes 'like a smile'. Blossom should be soft and round and grow from its heart, which the Chinese compare to the hole in the centre of a coin.

Plum blossom can be painted either in the outline technique or with solid strokes, but in both cases life is given to the flower by the addition of the anthers, stamens and pistil. Stamens should be 'as strong as the whiskers of a tiger' says the basic Chinese instruction book and the anthers dotted 'like grains of pepper' or 'the eyes of crabs'.

Other blossom is composed in a similar way, but none are quite as striking to the 'Chinese eye' as the purity and strength of plum blossom.

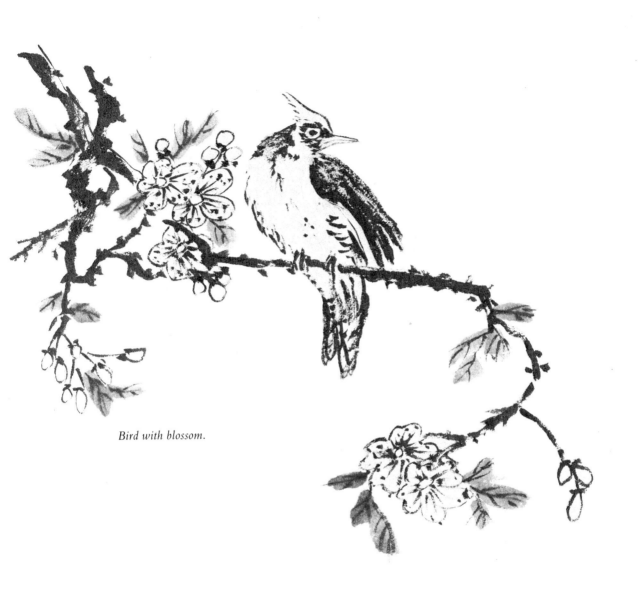

Bird with blossom.

Landscape Painting

Landscape always has been, and still is, the great subject of Chinese painting. Mountains were not only the magical abode of spirits, but also the centre of the four directions of the Universe. Nature pervades everything, but the Chinese landscape is composed of symbols or ideal types. Thus there is a specific method of painting the elm-type tree, willow or pine. It is not possible in reality to 'copy' nature, therefore the intention is to 'create' a landscape painting. This creation can best be described as an aristocratic production.

The simple landscape opposite, basically trees and rocks, has been painted with very wet brush strokes. Each stroke is made by placing the brush length sideways on to the paper and allowing the wet black ink to run.

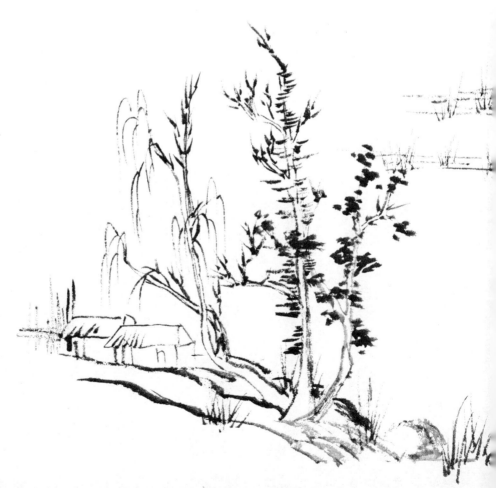

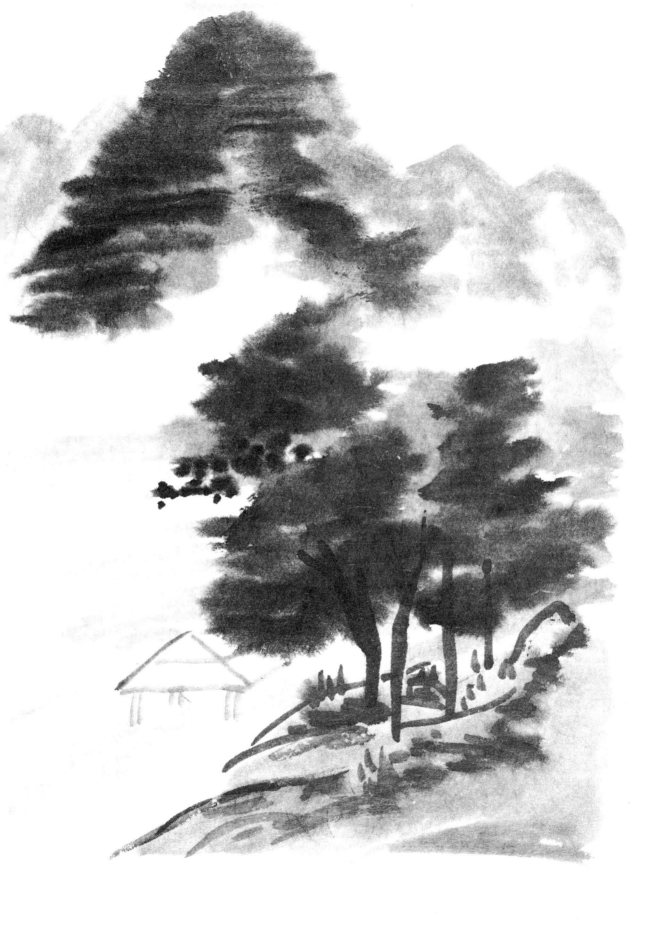

Mountains

The basic overall structure is the most important idea to bear in mind when starting to paint a landscape, particularly a large one. The ancient Chinese painters divided their space into three or four main sections and then worked from there, first establishing the general outlines of the mountains. The later details and individual changes of brush strokes can be worked out when the whole composition has been planned.

The great master painters of the past had a saying 'yu pi yu mo' which means 'to have brush, to have ink' and implies that outline without the brush strokes that give it depth is as bad as having the solidity of the ink strokes without the clarity of the outline. Both these requirements are necessary parts of the effective whole. Usually it is the crowning peak which is the dominant overall mountain; others are added, sometimes in a subservient position, and at other times side by side as though friends. Too many peaks will not make a successful painting as the effect will be dull and monotonous. Mountains are often described as being in a 'host-guest' relationship – in fact these friendly groupings are an integral part of rock and tree groupings as well as mountain arrangements.

Rocks

From ancient times the Chinese have regarded rocks and stones as more than mere geological matter. The medicinal qualities of their mineral ingredients have given rocks a magical connotation. Rock is the backbone of the earth and the element which gives it its strength. As it comes in so many forms, it can be interpreted in a variety of decorative ways, all of them involved with the basic Yin-Yang principle so inherent in landscape painting. A quotation from Tsung Ping sums up the Chinese idea as follows: 'Landscape paintings have a material existence and also a spiritual influence.'

To the Chinese it is essential that even a rock has a spirit of its own; this quality is as basic as their formation and the Chinese call it 'ch'i' The first outlining of the rock should have life otherwise everything that follows can be worthless.

Light ink places and outlines the rock and then the modelling brush strokes follow to give the rock its three faces. Either dots or lines to represent the veins are placed inside the outline until the rock emerges as a living form. The side of the brush is used for rocks whose moulding lines are straight, while the point is the vital part of the brush for rocks whose modelling lines are like 'tangled hemp fibres'. Picturesque descriptions for the methods of delineating rocks abound: Fan K'uan used 'ravelled rope' strokes; Ma Yuan's strokes were like 'brushwood in disorder'; Hsia Kuei described his brush strokes as 'big axe cuts' and Wang Wei as 'veins of a lotus leaf'.

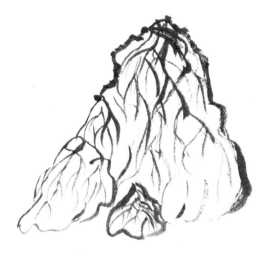

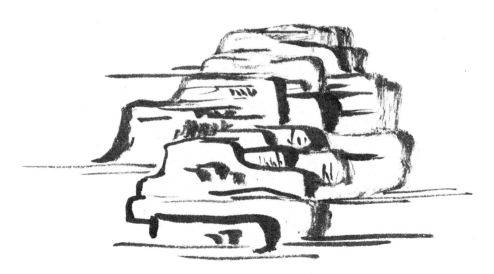

How to Paint Rocks

Using the lightest possible tone of black ink in the beginning and a featherlight touch on the paper, draw the point of the brush up to the top of the rock and then continuously lay the bristles down and gently pull to the right. Then push horizontally to the left. (This description is for right handed people. If you are left handed you should reverse all the instructions). Step by step darker tones can be added. Each brush stroke should move and turn with abrupt stops as this gives angularity and volume to the rock.

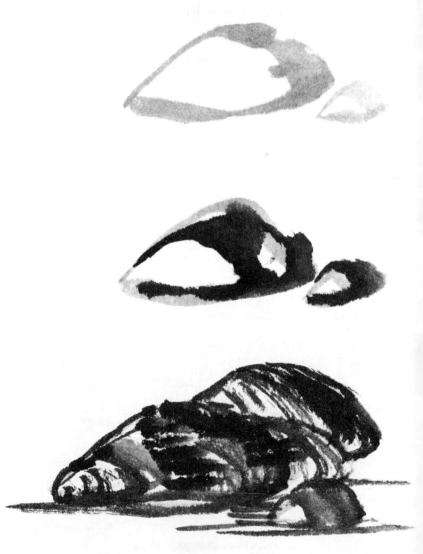

Small rocks can build up into large mountains by indicating the outlines and then adding crevices and hollows. For clouds and mists washes should be soft and light among the mountains.

When planning a picture, first work out the proportions of the sky and earth; the top half is sky space, the bottom half is earth space and in between are organised the details of the landscape.

A Chinese saying goes 'Learn from the teacher, but avoid his limitations'. Eventually each painter will develop a rock painting method which will give life and form to the rocks of his landscape picture.

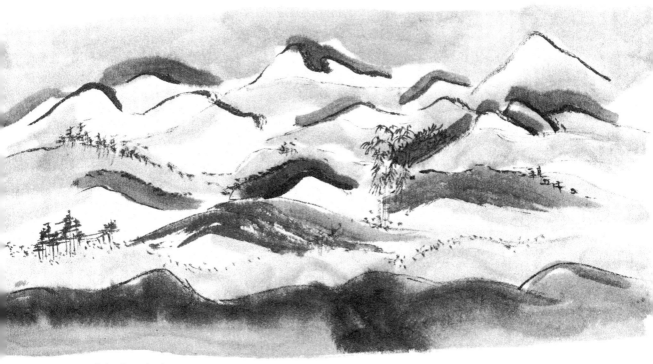

A painting of clouds and mist.

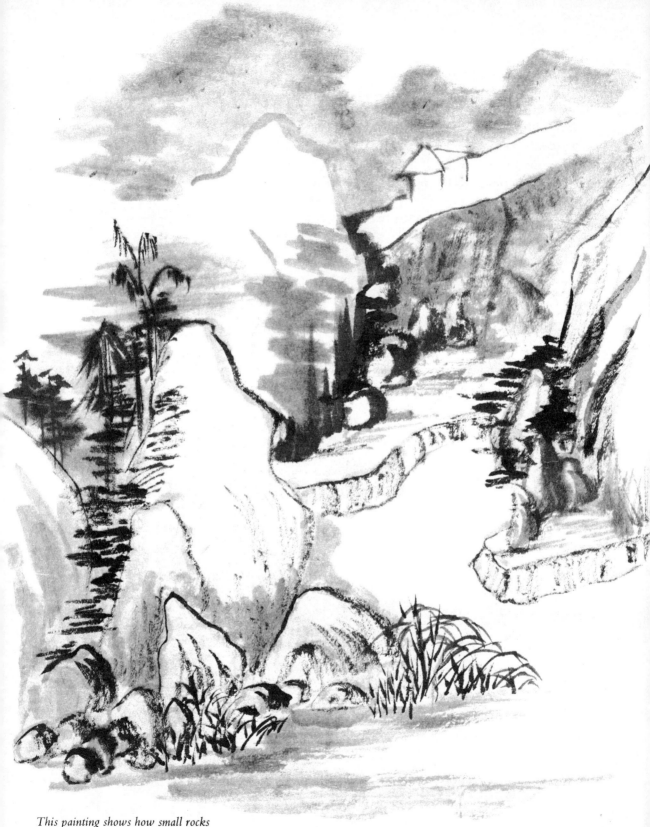

*This painting shows how small rocks
build up into groups, then grow into mountains.*

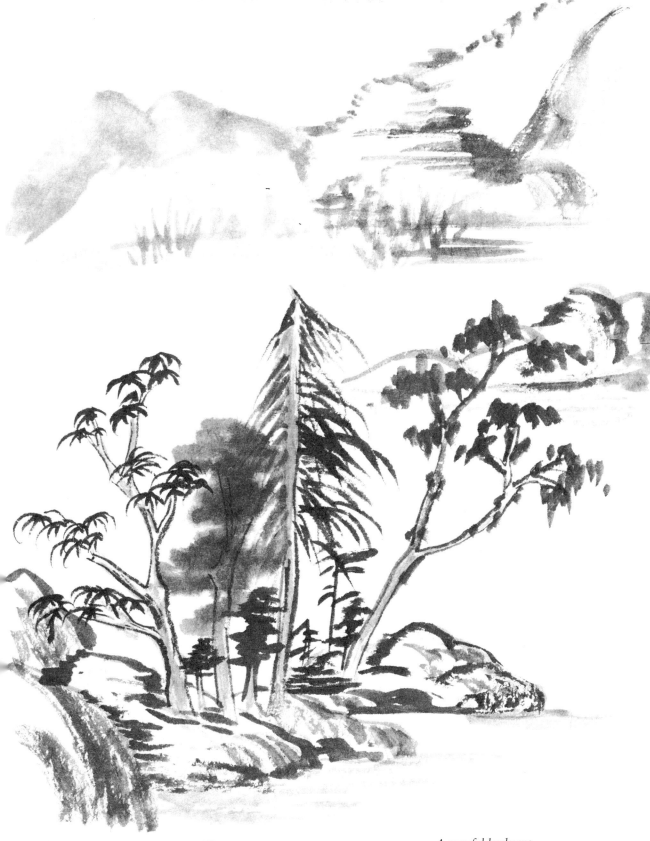

79

A peaceful landscape.

The Four Chief Stages in Landscape Painting

The four chief stages in landscape painting are outlines, shaping lines, dots and washes.

1 Outlines

Outlines can be superimposed over each other in several layers of ink, usually lighter ink first, although it is possible for the really expert painter to work the other way round. Changes and corrections can be made as layers build up from light to dark. The effect is more subtle and less committed when the outlines are painted in this order.

2 Shaping lines

There are outlines for rocks, mountains and trees made up of 'shaping lines' which meld together to form the landscape and which give it its style. These lines can be compared to handwriting, in that, even when trying very carefully to achieve a certain style of shaping line, the result is dominated by the painter's own personality traits. It becomes impossible to efface individuality even when trying exceptionally hard to achieve a specific type of modelling line.

Three main categories of line have been loosely defined, each with their own picturesque description of the minor varieties. *Thread shaped lines* can be described as veins of lotus leaves; hemp fibres; cow hair; whirlpool eddies or lumps of alum, while the *band shaped lines* are like axe-cuts of different sizes or horses' teeth. The third category, *dot-shaped lines,* can be like thorns or raindrops or the ubiquitous 'mi dots'. However, a painter eventually develops his own types of shaping lines, instinctively choosing the type which will best describe the intentions of his painting.

Although the basic shaping lines are clearly defined, they can be made to appear totally different as variable factors, such as the dryness of the brush, the angle at which the brush is held and the pressure and speed of the brush movements, are taken into consideration.

Brush movements. *Use a small brush, lightly loaded. The brush moves in the direction of the arrows and in the order shown.*

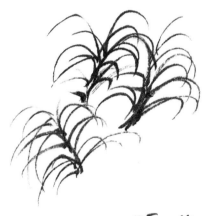

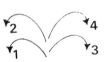

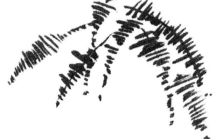

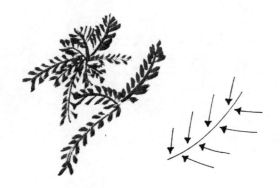

Work from very light centre line. Use small brush, with medium ink loading.

Rather wetter brush, placed on the paper with a sideways movement, allowing some ink to run.

Small brush, held vertically over the paper, with medium loading. Brush not to move too slowly.
Stroke starts at the top and brush moves down.

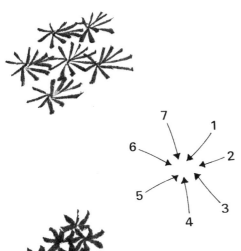

Brush moves from the outside towards the centre, eventually completing a full circle.

Brush to be loaded with rather more ink, and moved slightly more slowly, but still as above.

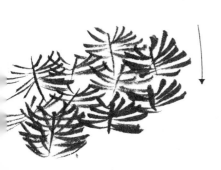

Begin with centre line. Then work from the outside inwards.

Use medium brush with medium loading.
Remember to vary the shades of ink used to paint these shap
lines, although to begin with it is always easier to paint with th
ink.

Brush laid down horizontally, point to the left.

Brush held vertically, allowed to touch the paper.

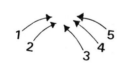

Rapid brush strokes, forming a fan shape, with movements from the outside towards the centre.

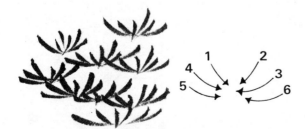

Fan shape formed by brush strokes made in the order shown.

3 Dots

After the basic structure of the landscape painting has been clearly delineated, any necessary dots can now be added. These serve to emphasise any lines which need to be strengthened or can be used to remove the impression of over-smoothness of tree trunks or rocks. Although dots, like lines, have tendencies towards the horizontal, vertical or diagonal, they can be varied by different brush usage and even superimposed on each other in variable ink strengths. There are many different kinds of ink dots in the same way as there are a myriad varieties of grains like pepper, salt, sand or pollen; some are soft and should be painted with loose wet ink; others are hard and best expressed with a dry brush.

Dots can be used to emphasise the folds of the hills or to show distant vegetation; or put together in varying combinations to indicate other elements of the landscape.

4 Washes

Sometimes a landscape painting will not require any wash, either in ink or colour, but usually some form of space filling is required. There are two types of wash which may be used, although they are often painted in conjunction with each other. Small areas of wash, for instance, on rocks or foreground can help to give added perspective to the composition. An overall wash on large areas of painting is called 'jan'. It is very important to keep this wash even and not to use too heavy colour. It is also customary to put an overall wash on top of the smaller areas which have already been painted so it is vital neither to over-soak the paper with liquid, nor to scrape the surface of the paper when applying paint to large areas. Occasionally when using very white paper for landscape painting, it may improve the composition to cover the entire landscape with a wash of tea, thus giving a ready-made ageing effect to the painting. Tea is, after all, a natural stain and practice and experience can determine the degree of concentration required to attain the exact colour needed. Once again, care must be taken not to scrape the paper surface or tear it when it is vulnerably wet.

Chinese landscape painting is called 'shan-shui hua' which means 'the painting of mountains and water'. It also embodies the Yin–Yang principle which underlies Chinese philosophy. The male element, yang, is the mountain and the female element, yin, is the water. Water is the weakest element in the universe, but by continuous soft pressure it penetrates and weakens the hardest of substances, like rock, so that eventual erosion is inevitable. Water is rarely the main element of a Chinese landscape painting, but it is almost always there – implied, if not actually seen and all pervasive in its presence. It is not delineated by small elegantly described rivulets and waves, but by space in the foreground, waterfalls hiding at the back, or snow lying gently on the hills.

Use of Colour

Ink is always the central core of Chinese painting, but colour can help to provide more realism. All the ink strokes should be completed first before any colour is added, though it may in fact be the case that a particular composition stands in its own right without the need of any colour at all. Otherwise the use of water colours, which are, of course, transparent, will give the picture additional realism while allowing the brush strokes, the essence of Chinese painting, to show through.

One of the difficulties which has occurred as a result of modern progressive developments is that water colours are no longer pure pigments, but contain additives which help to maintain free flowing qualities in the paint, or alternatively keep the colour intensity fast under difficult light conditions. These very advances cause difficulties to the modern Chinese painter as some of the twentieth century man-made 'improvements' do not, in fact, meld with the ink and rice paper in the same way as the original pigments.

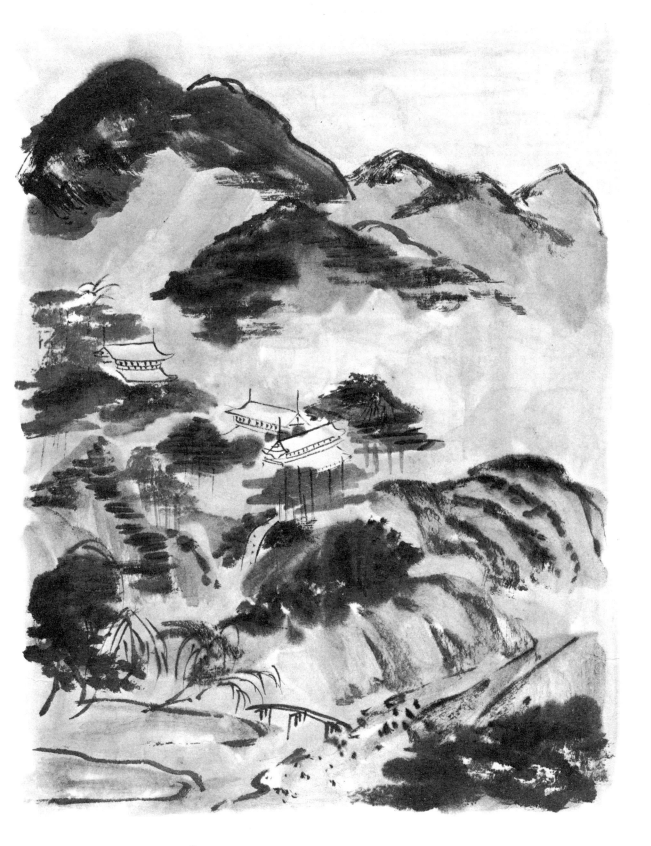

Perspective

On a two-dimensional surface the appearance of three-dimensional space can only be an illusion. The ability of the painter to convey this illusion is the essence of landscape painting. The Chinese use two methods: first, by making the objects diminish in size the further back they are and second, by making distant objects indistinct and painting them in a paler colour.

There is no focal point in a Chinese landscape; it is all open to be viewed from any position, but the painter himself keeps a persistent position which falls into one of the three main categories allowed for the landscape artist.

1 *High Distance* (kao yuan)

Looking at a peak from the bottom upwards. This gives a precipitous view as the eye moves from the base of the picture upwards.

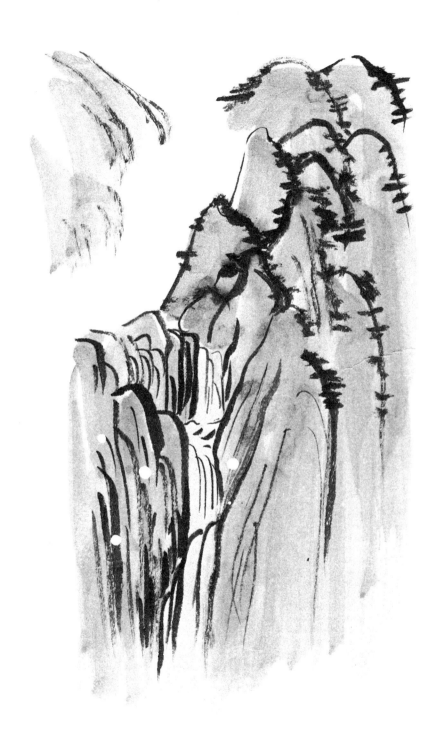

High distance (kao yuan).

2 *Deep Distance* (shen yuan)

Looking across from a foreground mountain to one at the back of the picture to give the effect of many different layers to be viewed as the eye travels from front to back.

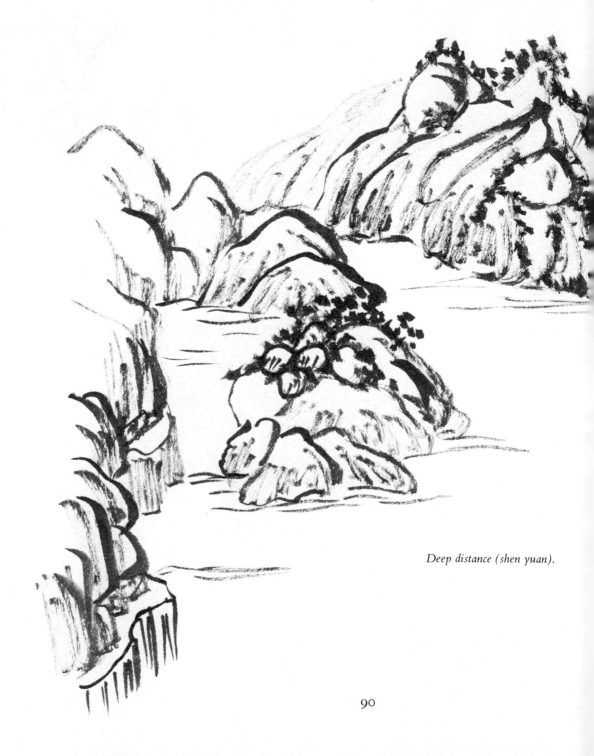

Deep distance (shen yuan).

3 *Level Distance* (p'ing yuan)

Looking from a place in the foreground into the far distance across a flat landscape. The eye can encompass the entire view calmly and without much eye movement.

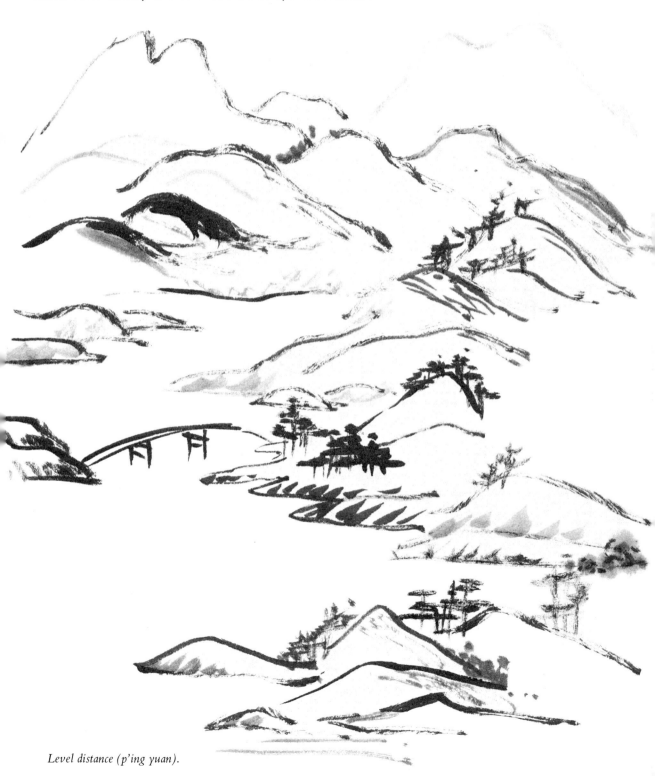

Level distance (p'ing yuan).

Kuo Hsi, in the early part of the eleventh century, added these comments to help clarify the three types of landscape painting. In high perspective, everything appears bright and clear with human figures quite definite; in deep perspective, objects are deep and heavy with human figures appearing to be broken up; while in the third category, there are shadings which are light and shadowy with figures appearing in very soft focus.

Specific sizes are important too. The mountain is bigger than the trees and the trees are bigger than the men. In fact Taoist philosophy almost demands that the size of man should be underemphasised to give it its correct importance in the overall plan of Nature – people being regarded as of very small significance in the general order of things. Kuo Hsi also said 'In landscape, paint mountains in tens of feet, trees in feet, horses in inches and humans in tenths of an inch'.

Additional elements can be introduced into the landscape painting to add extra emphasis to each different type of perspective structure. Mountains can be made to appear higher by the addition of waterfalls, or huts nestling at different levels on the hills. Mists and variable breaks in the many planes which make up the landscape in depth can help to extend the distance, while flowers and birds in the foreground of a level perspective landscape maintain differential interests.

Drawing Trees

There is an accepted order for drawing trees as indeed there is for all parts of the Chinese landscape. First the trunk is drawn, then the main branches, followed by the foliage.

Branches fork out like roads and paths. Two trees together are composed either as a large tree with a small tree added (called 'fu lao' meaning carrying the old on the back) or if painted the other way round, then it is regarded as 'hsieh yu' (leading the young by the hand). Trees should not all be the same height with roots and tops on the same levels, but should appear to be growing naturally together.

Pine Trees

Pine trees are very important to the Chinese landscape painter, not only to the actual composition of the picture itself, but also because the tree represents so many fine virtues and high principles. Its inner strength symbolises the inner virtues of man, the potential which is available ready to be tapped. The tree itself is often compared to a dragon, a symbol of power, either lean and strong, coiled ready to emerge, or old and sturdy and as strong as iron. Many great painters have used pine in their landscapes, each in an individual style of their own. Ma Yuan used split brush strokes for the pine needles, while long thin needles on great tall pine trees were the speciality of Wang Meng. Anyone visiting a pinetum will have realised just how many variations there are of the simple pine tree. Observation will always help the painter, but simple decorative elegance and careful brush strokes will always produce extraordinary results. Trees in the foreground of the landscape will have a great deal of detail you can show, remembering always of course that it must be in the correct proportion to the overall composition; while those in the background will have progressively less and less detail, culminating in a series of vertical lines with small horizontal 'rice' strokes to indicate distant pines.

One individual branch of a pine tree is sometimes used as a complete composition in its own right, in which case each needle assumes very great importance. The size, and

number, of needles per group has to be varied according to the general size of the pine tree composition.

When looking at pine trees as part of a larger landscape the general impression is often of fan shaped areas of green or grey through which the needles shine. To represent this on paper, the needles are drawn first with the brush and then soft wet brush strokes provide the overall softening effect.

pine needles *shape*

order of painting

group shape

needles in group shape

grey small wash added

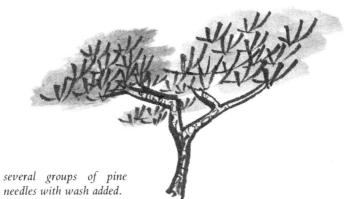

several groups of pine needles with wash added.

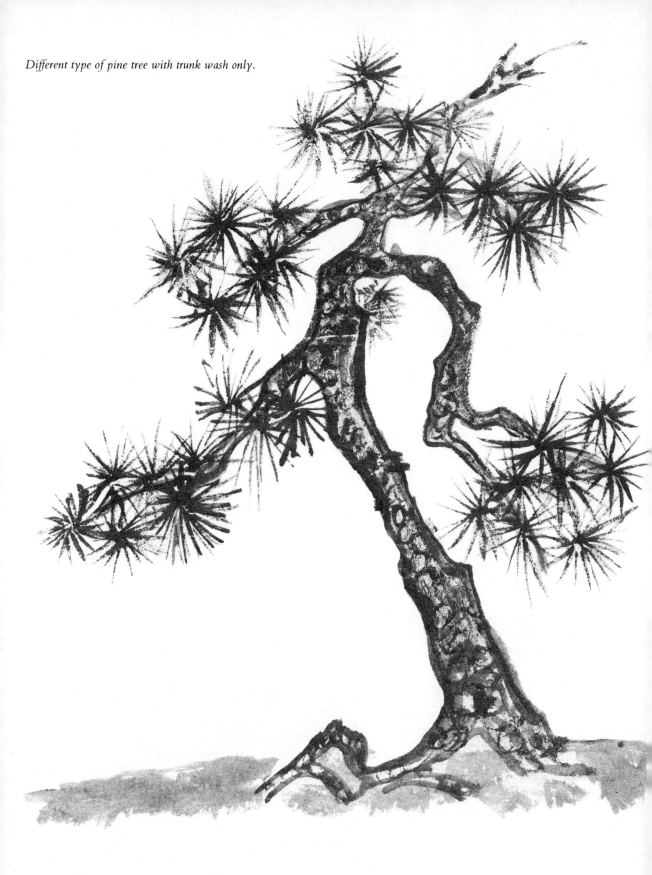

Different type of pine tree with trunk wash only.

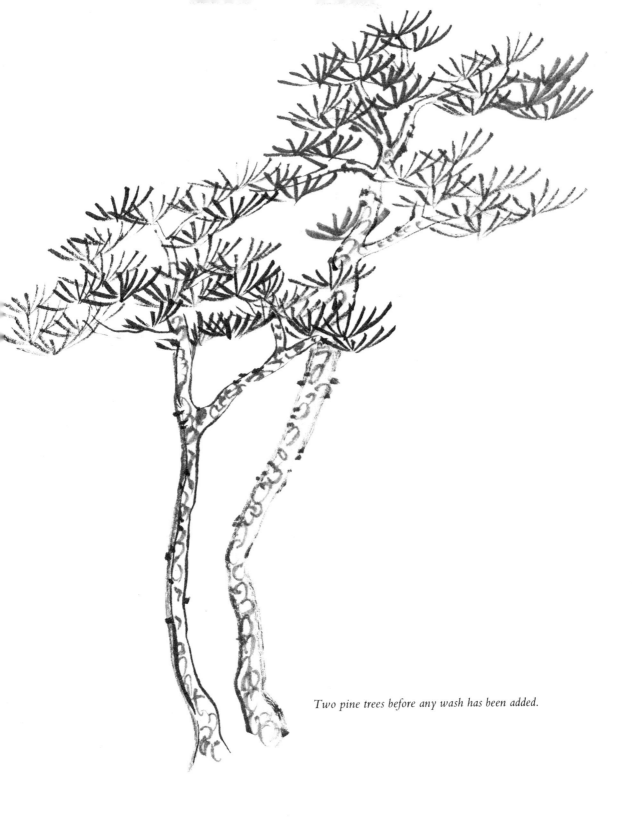

Two pine trees before any wash has been added.

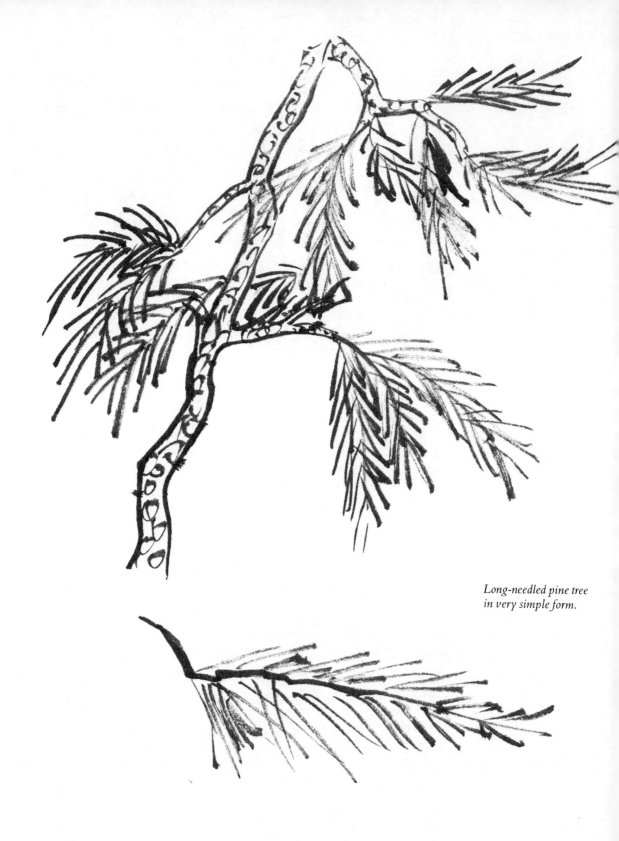

Long-needled pine tree in very simple form.

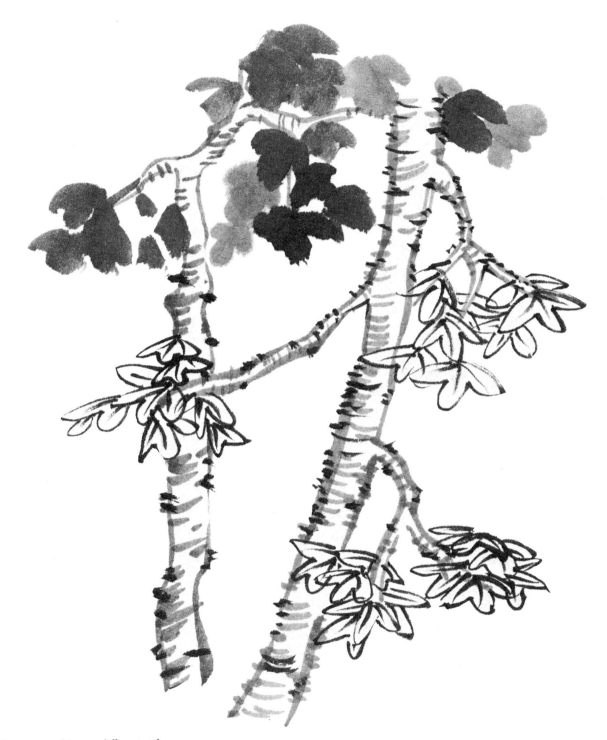

A tree painted in two different styles.

99

Other Landscape Trees

Many other trees figure quite largely in the general
landscape composition, as the tree cult has symbolised life
and death from very early times. Hollow trees were
regarded as being filled with spirit and were particularly
significant. ('Spirit' here implies life feeling.) The
mulberry tree has roots reaching into the nether regions
and branches ascending to the sky above; the sun climbs it
every day according to ancient mythology. The Cassia is
the tree of the night and darkness, and its flowers are
described as 'luminous stars lighting the world before
sunrise'. All manuals on Chinese brush painting describe
the Wu Tung tree (dryandra) since it is associated with the
legendary phoenix. The willow tree, always associated
with and usually painted with water, is a favourite tree in a
small landscape composition and much appreciated by the
Western admirer of Chinese art. There are several methods
of painting the foliage; one is to outline the leaves and fill
them in with green; another is to paint the leaves directly
in yellow green in the single stroke technique or, of course,
ink monochrome can be used with great subtlety to
achieve the same results.

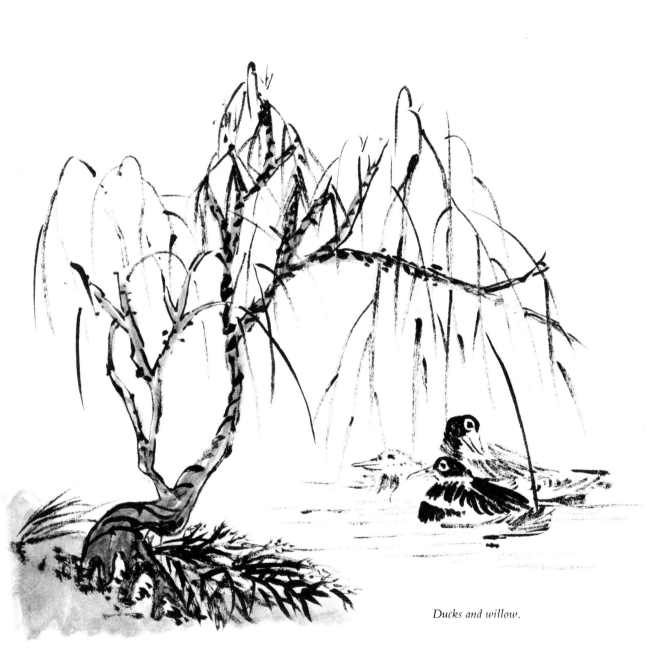

Ducks and willow.

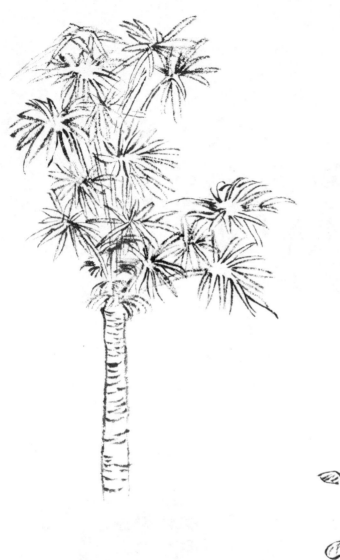

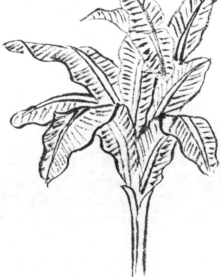

Two types of palm tree in outline technique.

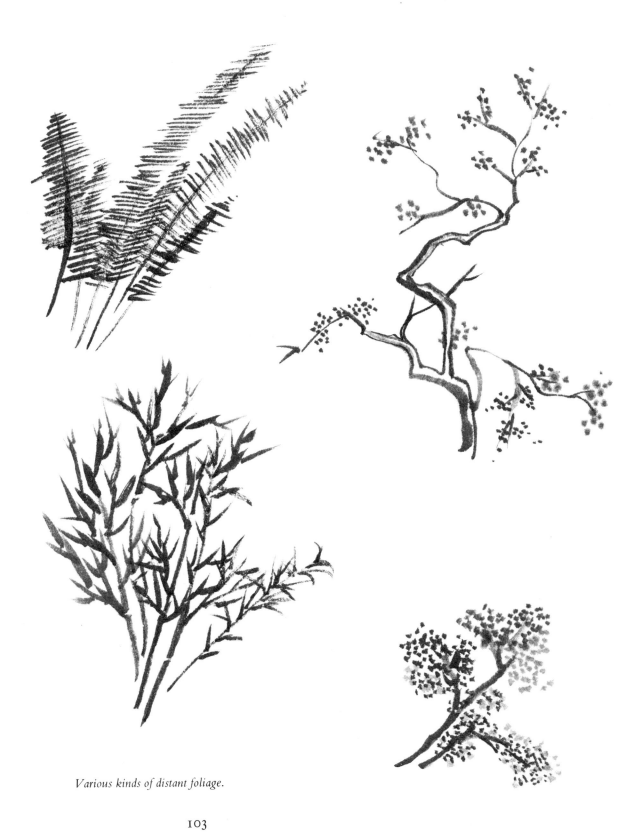

Various kinds of distant foliage.

103

Different kinds of tree foliage.

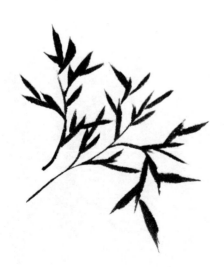

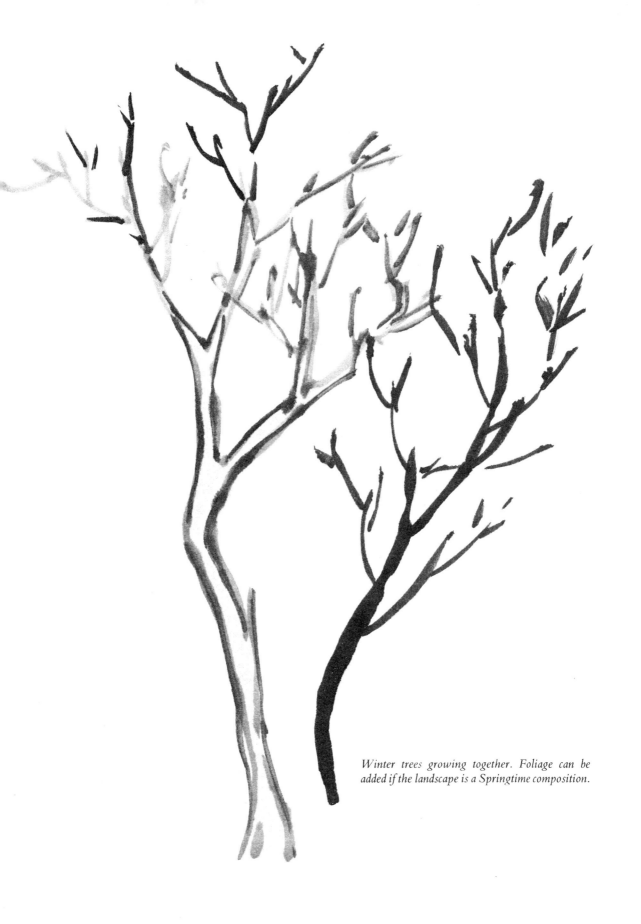

Winter trees growing together. Foliage can be added if the landscape is a Springtime composition.

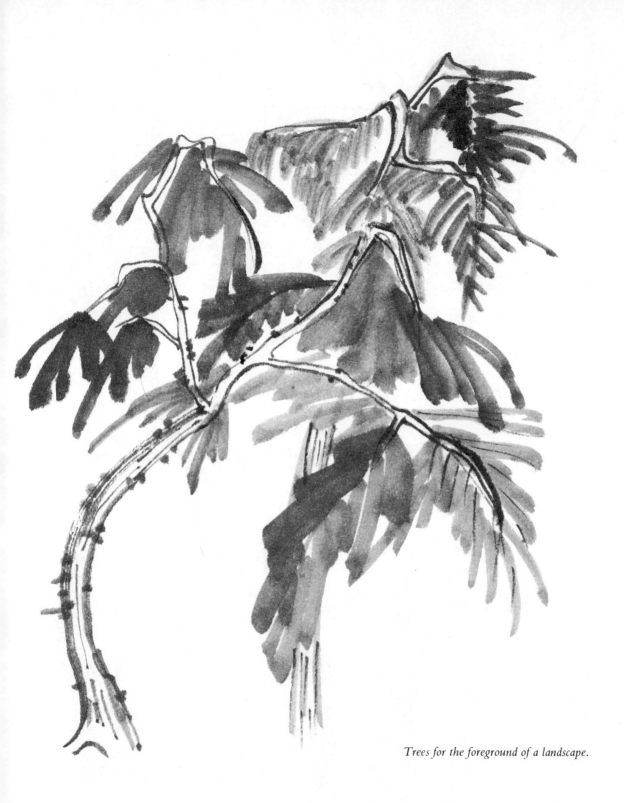

Trees for the foreground of a landscape.

106

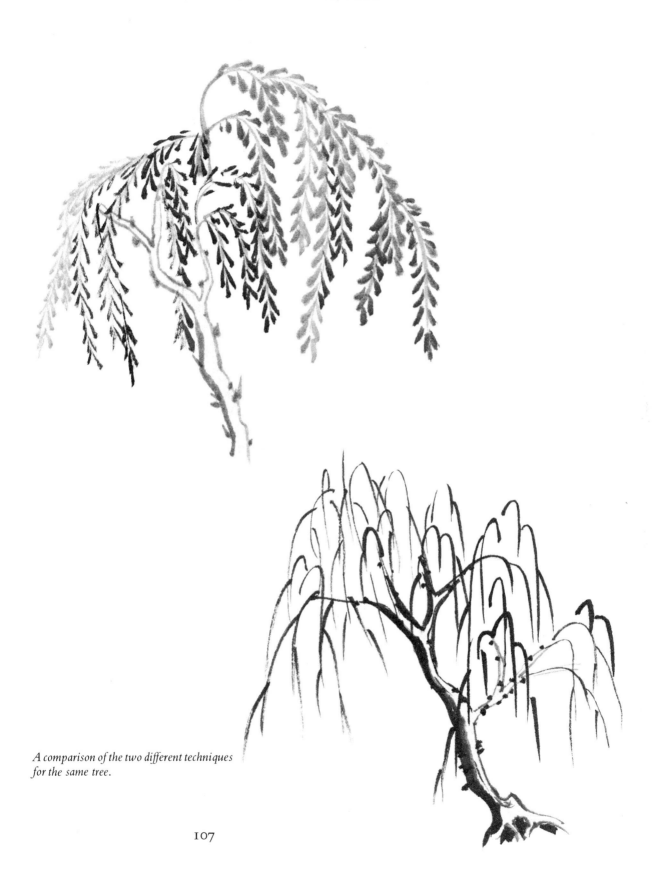

A comparison of the two different techniques for the same tree.

Waterfalls

Some form of water is almost an essential in a true traditional landscape painting. Water is the life blood of Nature, but even more important, it gives life and vitality to the rather static form of landscape which is so favoured by the Chinese painter.

It can be said that while rocks form the basic structure of mountains and therefore landscape painting, water forms the rocks and the mountains.

A waterfall may be shown as a small, gently flowing water way or as a powerful substance which has cut through a steep mountain gorge. Wang Wei described the painting of a waterfall as an idea having 'interruptions, but no breaks'; in other words, the brush may stop but the thought continues. One device which was often used was to have clouds partly obscuring the waterfall, so that some of the flow is implied rather than actually seen.

On no account should water appear from nowhere in an impossible manner as this would immediately render the landscape painting worthless.

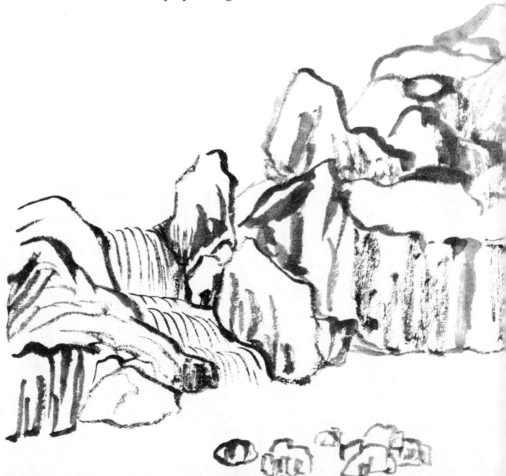

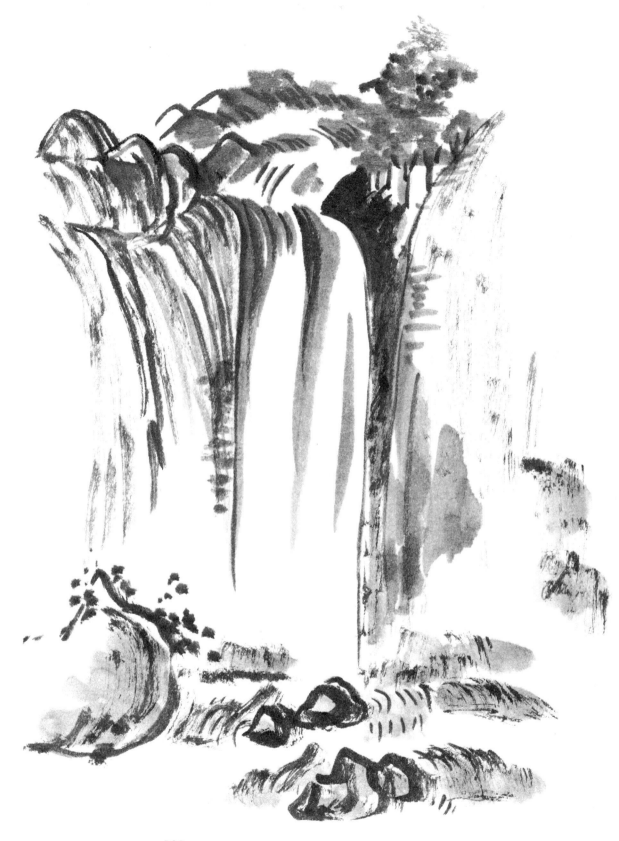

People and Things

Landscape painting does not have to have people and things in it, but they are often a useful means of conveying size.

Figures are usually drawn carefully with a fine brush, but not in too much detail. Figures should be kept in proportion to the trees as far as possible, but should on no account be painted larger than a mountain even if normal non-oriental rules of perspective seem to require it. Man, to the Chinese landscape painter, is a very insignificant part of the overall conception and as such should be shown by his size to be so.

The viewer of a landscape painting should want to change places with the person in the painting. A figure contemplating the mountain or playing a musical instrument, or a philosopher relaxing by a mountain stream; all these contribute to the overall composition without distracting from the scenic beauty.

In some cases, although it is obvious what the people are doing, they may be drawn so freely that they have no eyes or ears or other fine detail. Still, they contribute to the general effect without impinging too much on the peaceful aspect of the Chinese landscape. Animals and birds, although they may seem to be only a very small part of the landscape painting are in reality playing a large part as they are helping to convey the season or the time of day. They also help to give a feeling of life and some vitality to a rather stationary art form.

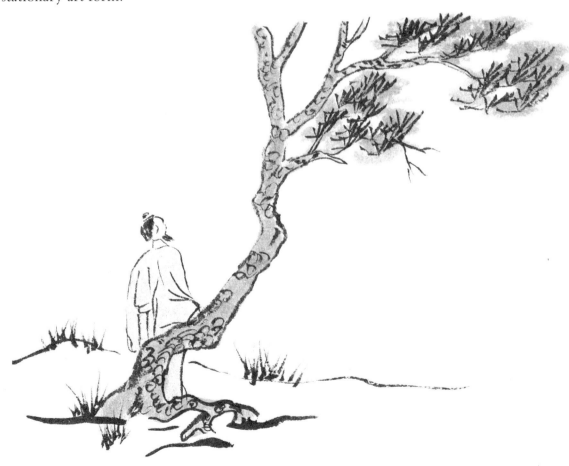

Houses

Usually a landscape will contain some kind of dwelling. The Chinese regard the doors and windows of these dwellings in the same way as eyes and eyebrows; it is where they are placed which is important and how they are positioned. Without them the house is 'blind', but with too many doors and windows, the house would become ridiculous. Landscapes acquire life from both dwellings and people, but if overpopulated the peace and tranquillity of the painting could be ruined.

Buildings rising on the levels of a mountain slope.

Thatched dwellings. These can be used in summer landscapes, sometimes with open windows, or occasionally with the windows closed up.

Houses suitable for flat areas.

A hut and its gate – a natural scene filled with life. It can be used in landscapes – in rain or in snow. A vine grows untidily across the gateway as this small cameo conjures up visions rather than carefully explaining facts.

The Twelve Faults
as listed by Jao Tzu-jan

These are the faults to be avoided in landscape painting and indeed if all these errors could be averted, then the painting would be well on its way to being a work of art:—

1 A crowded, ill-arranged composition.
2 Far and near not clear.
3 Mountains without life.
4 Water with no source.
5 Over simplified landscapes.
6 Paths with no beginning or end.
7 Stones and rocks with one face.
8 Trees with less than four main branches.
9 Unnatural figures.
10 Buildings in the wrong place.
11 Mixed atmospheric effects.
12 Colour applied without thought.

If this list is studied carefully, it becomes clear that most of these faults have already been mentioned in the course of each individual description of the different parts of landscape painting which fit together to make the whole. However, while it is easy to remember when one is only concerned with one aspect at a time, it is much more difficult to maintain the level of concentration required to ensure that not a single one of these mistakes creeps into an entire painting. One small consolation, if such it be, is that it is obvious from the list that even the best of the ancient Chinese painters was not immune from making the odd mistake, otherwise there would clearly not have been any need for this list.

It is also, in a way, a reminder of the fact that the Sixth Principle which encourages the learning of technique by copying is invaluable in the progressive learning of the ancient art of Chinese Painting, for it will always enable the tyro to concentrate on single aspects of technique while using the basic composition and style of someone else as a working base.

The Seal or Chop

When or who started the practice of appending a seal to a painting or work of art is rather obscure, but without doubt it is of the utmost importance.

The first seal placed by the artist, shows its authenticity and may be followed by another different one, possibly to depict another facet of the artist, in the form of a nom-de-plume or artistic symbol. These two almost certainly would be of the basic two types; one with the characters on the seal carved in relief, giving red characters on a white ground with a red border, cameo form, and the other being carved to produce white characters with a red background, intaglio form – yet another oriental preoccupation with Yin and Yang. Many seals are themselves works of art and if made in ivory or jade, greatly prized.

Owners of paintings or their friends would possibly add their own chop, partly to show their approval, but also to give a visible record of the pedigree of the painting, who owned it and when. The owner or collector could also add a written dedication (a colophon) to any painting he liked, but these frequently became cumbersome or ill-placed and destroyed the basic beauty of the original painting.

A good seal colour will not run or fade for hundreds of years, but needless to say the quality of the ink may vary and can be an expensive item. It is a very thick sticky red paste made of cinnebar (mercuric oxide) which gives the red colour, oils and shredded raw silk and to use it properly requires practice and patience. The seal is pressed into the ink a few times and is then transferred onto the painting, making sure that firm even pressure is applied to gain an imprint which will remain legible for a considerable period of time.

Opposite: a selection of authentic chops ranging from the twelfth century to the twentieth century.

As in the case of all materials used in Chinese brush painting, the seal used, the colour of the ink and the actual application are all part of the artist's ritual.

The seal makes the painting complete; the small splash of distinctive red often stands out quite prominently and it is, for beginners as well as the experienced artist, a touch of realism and authenticity. But to obtain a handmade chop (and all are individual in both manufacture and creation) is not only expensive, but a long drawn-out process. Therefore to make your own is a useful and interesting exercise.

How to Make your Chop

Ideally your own name translated into Chinese characters would be most suitable, but very few European or Occidental names translate effectively enough into Chinese to make this worthwhile. As a compromise, therefore, the initials of your name could be used with which to experiment. Use them either as they are (e.g. ABC) or as a concocted 'Chinese – looking' anagram. This is actually not for the purist or fainthearted.

e.g. ABC could become

(twice size)

as JL into

(twice size)

Simplicity is the key to successful chop design in this way.

117

If on the other hand you are a flower painter or prefer birds etc. then a simple motif design can be made, but these latter types are only really fully effective when used in conjunction with another using characters of some description.

(twice size)

Whatever design or designs you choose, scale them down to about 2cm by 1.5cm, draw them reversed and check in a mirror that your reversing has been done correctly.

Transfer this reversed design on to a small piece of hard, fine grained wood, *bigger than your actual design,* which has been well sanded to a smooth and flat surface. Again check in a mirror that the design is correct.

Now, using a vice to secure the wood firmly, take an engraver or fine carving tool and slowly *either* carve away the design, thus leaving the surround which will be red when used, *or* carve so as to leave the design intact. The latter obviously gives the more effective result, but does take much longer and if you make a mistake or cut anything wrongly is impossible to alter.

Before trimming the block to the final size clean the surface and carved parts. Ensure that the final piece has square corners and straight sides. Other shapes are made, but often look out of place in company with pre-dominantly rectangular ones.

It is sometimes possible to find a piece of flat soft stone, soapstone for instance, with a smooth surface which can be used in much the same way as wood, *but* being more brittle, it is inclined, if extra care is not taken, to splinter and chip. Finally before you use the chop on a painting make sure the block is marked so that it shows which way you should hold it to ensure that it prints the correct way up.

Placing the chop on the finished painting is not difficult, but before the imprint is made, every care should be taken to find the best position, usually at the lower corners or upper corners. The first chop is never placed in the centre of the sides or within the painting itself. It may be considered as only a signature, but as it is very distinctive in colour, any error in its location will be most noticeable and could destroy the overall efficacy of the painting. Never append any other initials or signature and wait until the painting has been trimmed to its final size and shape.

Keep the chop surface clean at all times so that the outlines remain clean and not 'furry' and it goes without saying that the 'ink' is most indelible and every care must be taken to prevent it from being smudged – it does not dry instantaneously and as it is poisonous, it is not advisable to get it in the mouth.

The chop as printed.

The chop as cut.

Mounting the Painting

The characteristic shape of a Chinese painting, particularly a landscape, is long and thin. Mounted on a vertical scroll the painting may be compared to a ray of sun beaming from heaven to earth. The larger space above the painting represents heaven, while the smaller area below indicates earth. This space distribution is rather unusual to Western eyes and it takes time to become accustomed to it, especially since it is always exaggerated even further by the decorative silk mounting.

Although scrolling (mounting the painting onto a paper scroll) is an art form in itself and still practised in the Far East, more and more artists and collectors are having their paintings mounted under glass as the more valuable works of art can be protected from air pollution in this way. The basic proportions, however, remain the same for the discriminating artist. It is useless trying to adapt an oriental format to an occidental frame and vice versa.

Equipment

Starch paste (not one of the synthetic or cellulose types); large wallpaper brush with coarse hairs; and some thin card. This thin card must be the type which will not separate when wet – Antique Queen Anne board is most satisfactory.

Method

Lie the painting, painted side downwards, on to a very clean and well polished surface. Working tops of synthetic, shiny coverings, enamel topped freezers or even a window will do provided they are polished. Make sure the card is large enough to cover the painting completely. The paste should be mixed to slightly thinner than the instructions for wallpapering; 30 per cent more water is about right. Apply the paste with a well charged brush in a smooth flowing manner, always from the centre and continuing each stroke off the edge of the painting. After the first wet stroke, take great care to keep the free hand off the wet painting. The painting in this form is very liable to tear if prodded by fingers.

Any creases, folds or irregularities in the surface can be removed by patience and careful 'easing' of the crease from the centre to the edge of the paper. After the initial pasting, there is no need to hurry and the more care taken over this stage, the better the final result.

When the surface of the painting is flat, with all creases, lumps of paste, hairs from the brush, spots which seem to

appear from nowhere etc., removed – now is the time to lay the card onto the painting. This is best achieved by holding it a little above and slowly but accurately, lowering it onto the pasted surface. When this has been done and is in the correct position, firmly brush the two surfaces together. Again extreme care must be taken not to move the card once it has been placed over the pasted painting.

By checking carefully, it is possible to tell when the 'pre-mounting' card has adhered, and at this point, carefully lift one corner and in a controlled movement peel the whole from the table surface. The painting can now be mounted onto a more easily adaptable medium and should be laid flat to dry on newspaper. It is very important to ensure no contact between the wet card and any polished floor surface or your work may be ruined!

When the painting is absolutely dry, and it is emphasised that it must be *completely* dry, the next stage in the mounting process can take place.

It cannot be stated too strongly enough that both the basic preparation and the size and shape of the finally mounted painting will *not* be in accordance with the usual Western idea, but done properly it looks correct and not top heavy.

By placing a set square or straight edge on a perpendicular line in the centre of the painting it is possible to trim the painting to the required size and shape.

Basically a narrow form is desired with more space above than below the actual painting. Ensure that the finally trimmed card has square corners and if perpendicular in 'concept' the proportions should be: height $1\frac{1}{2}$ to $2\frac{1}{2}$ times the width; if width is more in evidence, then this should be 2 to 3 times the height. These are by no means hard and fast rules, but square or near square paintings are not at all acceptable.

The trimmed painting can now be measured to determine the size of the final mount. Ideally it should be mounted on a thicker card which can be white, coloured to accent a particular colour in the painting, or can be covered with a plain self coloured wallpaper.

The diagram (on p. 124) gives a guide as to the size of the mounted painting. Keep it narrow at the sides and allow extra space at the top if it will add to the overall effect of the painting. Apply a quick drying glue (but not impact adhesive) to the back of the painting, press it firmly and apply some pressure to keep it flat on the mounting board until absolutely dry.

If it is to be framed, any plain style will suffice and, to complete the whole, use non-reflecting glass. This will give a much better appearance to the painting and will add considerably to the preservation of its original lustre.

Possible Faults

Colours run. (This could be due to either applying the colour too thickly or not using the correct water colours. It is a good idea to try new colours on a rough piece of paper before attempting a full scale painting.)

Pre-finished painting appears creased or lined. (Due almost certainly to insufficient care and attention when pasting.)

Selected Bibliography

These books on Chinese painting are in English.

Chinese Landscape Painting, Sherman E. Lee, Prentice-Hall International Inc. Revised 2nd edition, ICON, Harper and Row paperback

Treasures of Asia: Chinese Painting, James Cahill, Skira, revised.

The Chinese on the Art of Painting, Osvald Siren, Schocken Books, New York, 1963

The Chinese Theory of Art, Lin Yutang, Heinemann, London, 1967

The Way of Chinese Painting, (the Mustard Seed Garden), Mai-mai Sze, Vintage Books, 1959. Revised 1977, Bollingen series paperback.

Chinese Painting Techniques, Alison Stilwell Cameron, Charles E. Tuttle Co. Inc., 1968

In Pursuit of Antiquity, Roderick Whitfield, Charles E. Tuttle Co. Inc., 1969

The Way of the Brush, Fritz Van Briessen, Charles E. Tuttle Co. Inc., 1962. Revised 1975

The How and Why of Chinese Painting, Diana Kan, Van Nostrand Reinhold, 1974

A Complete Guidance to Flower and Bird Painting, Choy Kung Heng, Wan Li Book Company, 1974

Ch'i Pai Shih, T. C. Lai, Swindon Book Company, Kowloon, Hong Kong, 1973